Maine ICONS

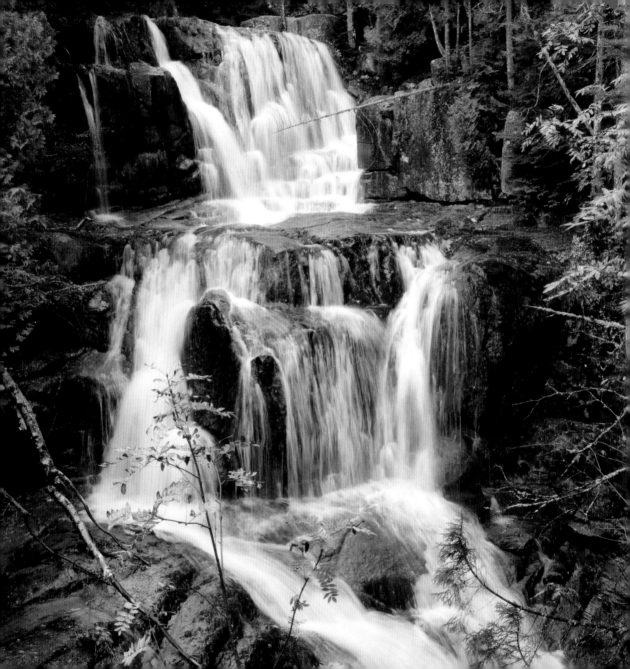

Maine ICONS

50 CLASSIC SYMBOLS
OF THE PINE TREE STATE

Jennifer Smith-Mayo
Matthew P. Mayo

gpp®

Guilford, Connecticut

*To Dale W. Kuhnert, whose infectious enthusiasm for Maine helped shape
and still informs our own love of this place, our lifelong thanks.*

To PB, writer, ranger, and friend.

To the Timms clan, our Maine chums.

To buy books in quantity for corporate use
or incentives, call **(800) 962-0973**
or e-mail **premiums@GlobePequot.com**.

Photos by Jennifer Smith-Mayo, except where otherwise noted
Text by Matthew P. Mayo

Project editor: Kristen Mellitt
Text design: Casey Shain

Library of Congress Cataloging-in-Publication Data is available on file.

ISBN 978-0-7627-5998-9

Printed in China

10 9 8 7 6 5 4 3 2 1

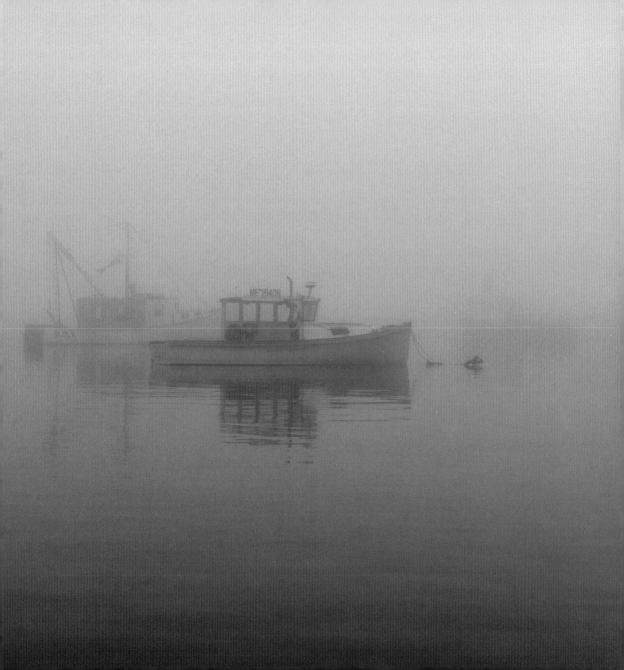

CONTENTS

INTRODUCTION

We have lived in Maine for two decades, and we'll still take any excuse (or none at all!) to travel throughout this great state—exploring, hiking, biking, swimming, poking, and prodding; talking with farmers, fishermen, lighthouse keepers, teachers, chefs, school kids, gardeners, singers, poets, and tourists. Each one is engaging, and each one shares our love of the Pine Tree State.

What is it about Maine that stirs people so? Is it her 3,500 miles of coastline? The more than 4,613 islands in the Gulf of Maine? The eighty million pounds of lobster hauled from her seas each year? The enchanting setting of massive Moosehead Lake? The 5,268-foot elevation of Baxter State Park's Mount Katahdin? Or is it her people—hardy, friendly folks who have grown used to inquiries about what it's like to live here year-round? Or perhaps it's the hard-to-define feeling that most people get when they cross the Piscataqua River Bridge into Kittery and read that life-affirming sign: WELCOME TO MAINE, THE WAY LIFE SHOULD BE.

Maine is many things to many people—a safe haven in a world of headaches, a fir-stippled paradise where summer comes slow and easy, a homeplace that is heartbreaking to leave and an immeasurable relief to return to. It is "Vacationland": an ideal mix of mountains and shore, lakes and streams, farm country and North Woods, island villages and inland hamlets, and a four-season paradise. What those from away might call isolated and slow, locals tend to think of as tranquil and sane.

Maine officially came into being on March 15, 1820, when, by act of Congress, she formally left Massachusetts and became the twenty-third state. But such an event falls short in defining this place where fly fishers wet a line on a crystal-clear river before a log cabin tucked deep in the woods at the base of a piney mountain. Where the silhouette of a lighthouse is slowly revealed as the sun rises far Downeast, where thick fog burns off by late morning and you can finally see the lobster boat puttering from trap to trap and can hear the lobsterman's off-key warble across the water as he sings along with Willie Nelson on the radio.

Where kids jostle and laugh in a lift line at Sugarloaf, where pink and purple lupines wave at cars from the roadsides, and where gardeners stock their farm stands at the end of driveways, setting out the "honor system" coffee can. Where a bull moose bursts the glassy surface of Baxter State

Park's Sandy Stream Pond, water running off his antlers, weeds dangling from his muzzle. Where the tang of wood smoke hangs low and inviting on a still, frigid winter afternoon, just before a nor'easter hits. Where children watch in awe as big, fat trout glide by in L.L.Bean's Freeport in-store tanks, and where a hot cup of coffee and a slice of pie at Moody's is just the thing before—or after—a long day at work.

In the course of putting together this book, we came across a number of amazing facts, figures, people, and places we were unable to include but wished we could have, among them: the Common Ground Country Fair, *Uncle Henry's Swap-and-Sell-It Guide,* Liberty Tool, fiddleheads, the white pine, the three-story outhouse in the Masonic Lodge in Bryant Pond, the world's largest frying pan (Pittsfield) *and* the world's largest coffee pot (Island Falls), the umbrella cover museum, the music-box museum … maybe not iconic, but darn impressive nonetheless.

Given that these are things we weren't able to include, just imagine what we were able to squeeze in. No single book could ever capture all that Maine has to offer, so this is instead a sampler of the most memorable icons from the state's length and breadth. We hope it inspires you—Mainer and visitor alike—to go farther afield in the Pine Tree State and do a bit of exploring, too. Maine is here and waiting—an old friend always looking for new ones.

Cheers,
THE MAYOS

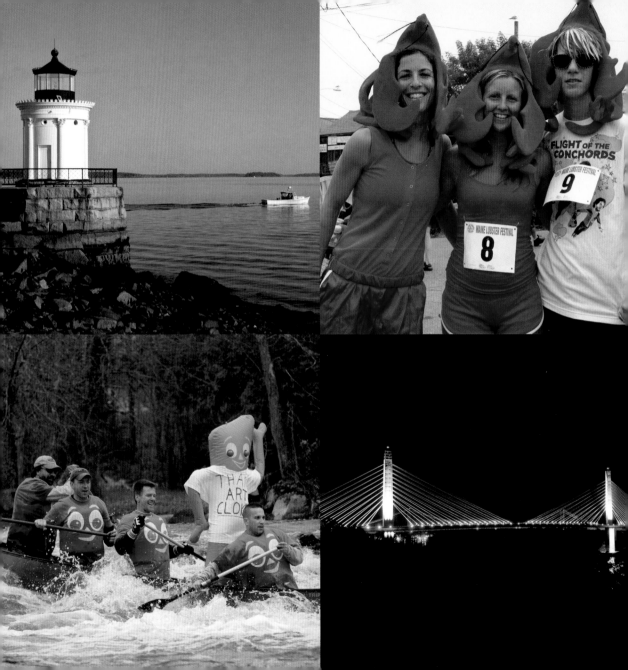

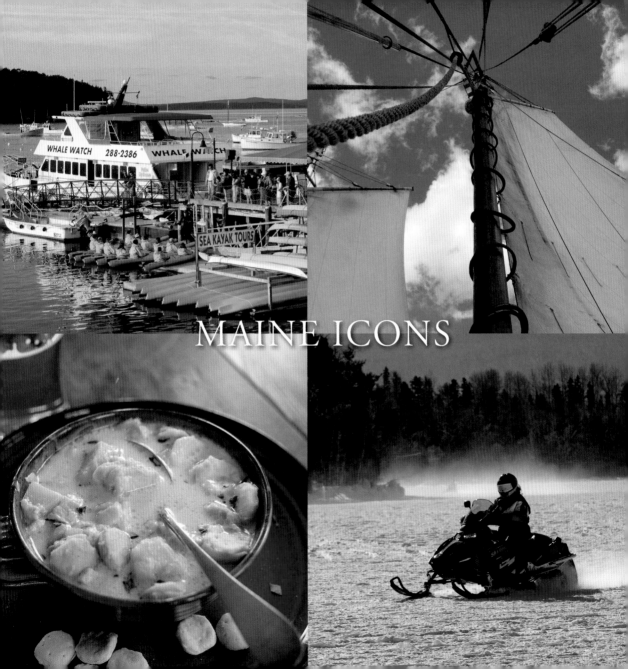

MAINE ICONS

MAINERS

The hardy, independent people who populate the Pine Tree State, be they of Native American stock or descended from the white Europeans who settled New England, share certain unshirkable traits that come with being a Mainer: the willingness to tuck in and do a job that needs doing, help or no; an unwillingness to suffer fools; a kindness that shines through even that gruff, guarded demeanor so common to all Yankees. Most of all, Mainers are a people with a strong sense of place that's matched with a pride *in* that place.

From snowmobiling in The County to swimming at Sand Beach, from ice fishing on Rangeley Lake to competing in the Kenduskeag Stream Canoe Race, Mainers genuinely appreciate where they live. They work hard and they play hard; they raise families and they honor their dead; they vote and they argue and they have even been known to shake hands and agree to disagree. In these respects, they are like most other Americans. And yet, because they live in Maine

For more information about Maine and her distinctive denizens, drop by www.visitmaine .com.

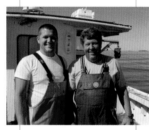

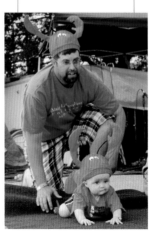

and are of this place, they are a unique bunch.

Most Maine natives, while they may agree with a few of those points, don't generally go in for such foofaraw, claiming that one can only be considered a true Mainer if one is born here. But even that isn't enough for a few old-timers, who insist on Maine roots at least three generations deep, untainted by those "from away."

Mainers have been known to indulge in an assortment of linguistic peculiarities, such as dropping the "er" from a word's end and replacing it with "ah"—as in the oft-referenced "chowdah" and "lobstah." And the phrase "come spring"—an oath almost threatlike in its power—carries with it the blustery force of a Maine winter, as in, "You wait, come spring you'll see who can grow peas." And there's that particular statewide favorite: "cunnin'," a term meaning the height of cute or clever, as in, "Those wrigglin' kittens are some cunnin'," or, "Don't he think he's some cunnin' for thinking he's figured out just what makes a Mainah tick."

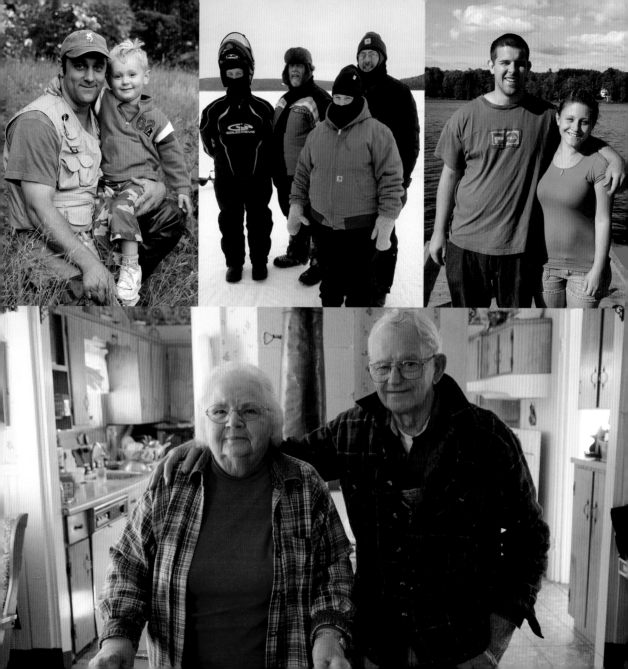

LIGHTHOUSES

Choosing a handful of beacons to represent all sixty-five of Maine's lighthouses is a bit like choosing a favorite child—they're cherished equally, though for different reasons. A number of Maine's beacons are in private ownership (with a couple offering unique overnight accommodations); others have been decommissioned over the years. Many are maintained by the U.S. Coast Guard and are still in use to guard Maine's rocky coast, riddled as it is with hidden obstacles lying just under the surface to tear a hole in a pleasure craft or supertanker.

Maine's southernmost lighthouse, Cape Neddick Lighthouse (or "Nubble," for the small island on which it stands), in York, is one of the most photographed lighthouses in the world. A bit farther up the coast sits Cape Elizabeth's Portland Head Light. Construction of the lighthouse began in 1786, making it Maine's oldest lighthouse. In summer, busloads of summercators visit the light, one of the state's most popular attractions.

Boon Island, a 300- by 700-foot rocky nub just 14 feet above sea level

Learn all about Maine's blinking beacons at the Maine Lighthouse Museum, One Park Dr., Rockland; www .mainelighthouse museum.com.

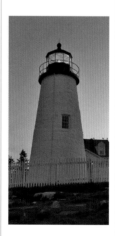

and 6 miles from York, is Maine's most unforgiving lighthouse location. Sailors who wrecked there in 1710 were forced to turn cannibal. In 1852 a 137-foot granite-block structure, the tallest in New England, replaced previous wooden efforts. The light has been automated since the vicious Blizzard of 1978 nearly killed the keepers.

The Midcoast Maine town of Rockland is home to the impressive Rockland Harbor Breakwater Light, at the end of the popular 4,300-foot walk along a granite-block jetty. Rock City is also home to the Maine Lighthouse Museum, which helps amateurs become aficionados in no time.

The most colorful lighthouse in the state is (almost) the most easterly, West Quoddy Head Light, distinctive in its candyish red-and-white striping. The sparkplug-shaped Lubec Channel Light is located in the shallow channel, roughly 500 feet from Canada. But because it's shorter than its more photogenic immediate neighbor, we'll claim the West Quoddy Head Light as the first lighthouse in the United States to see the sun rise.

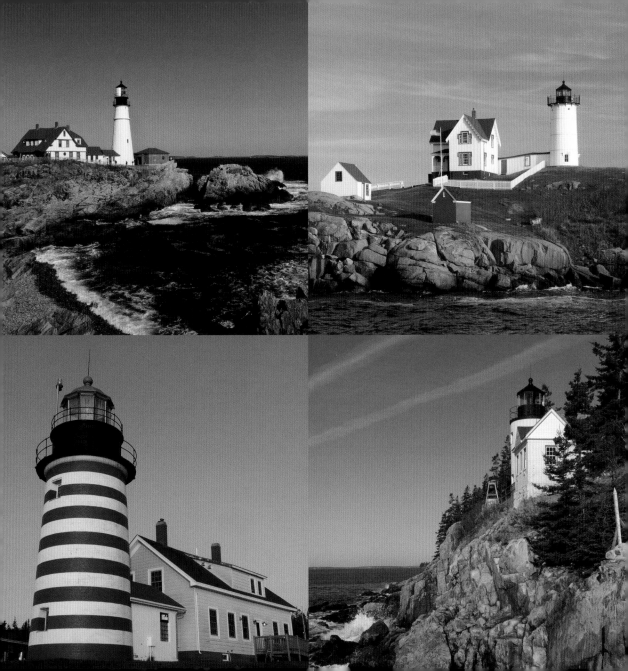

MOODY'S DINER

Back in 1927, an enterprising young man, Percy "P. B." Moody, wondered if folks driving up US 1 might pay a little for the privilege of clean sheets and a soothing setting. So he built three rustic cabins and charged $1 per person per night. Nearly a century later, Moody's Cabins has evolved into a motel sporting eighteen cabins and rooms (starting at a still-modest $54 per night), a gift shop just down the lane, and eclipsing it all—Moody's Diner, which P. B. built in 1930.

The diner now sports 104 seats, and from those humble beginnings until today, the Moody's enterprise has been a family affair, employing P. B. and his wife, Bertha, their children, and their grandchildren. But the real secret to Moody's is that it's a place where you can hunker down at the counter on a swivel stool, curl yourself around an ample slice of Four Berry Pie, a dollop of vanilla ice cream, and a hefty diner mug of coffee. And speaking of pie, every Thanksgiving, Moody's sells about 240

Drop in for a cuppa and a wedge of your favorite pie at 1905 Atlantic Hwy. (US 1), Waldoboro; (207) 832-7930; www.moodys diner.com.

of them, 180 of which are takeout. An average day sees fifty to sixty pies baked at Moody's, including the favorites: chocolate cream, Four Berry, and lemon meringue (with the loftiest peaks you've ever seen).

Not in the mood for pie? Even if commuters are running late, they'll stop and grab a cuppa and a pair of home-baked doughnuts, eight dozen of which are baked daily along with ten dozen muffins and forty dozen biscuits. No longer a twenty-four-hour establishment, Moody's opens at 5:00 a.m. Monday through Saturday (6:00 a.m. on Sunday) and serves a mean breakfast—all day long.

But don't forget lunch and supper. In addition to the usual diner fare, Moody's serves formative New England dishes year-round: a plate full of roast turkey dinner; a traditional boiled dinner (corned beef, cabbage, potatoes, carrots, beets, and turnips). And then there's fried tripe, Indian pudding . . . I could go on, but I'm getting hungry. Good thing there's always room at Moody's.

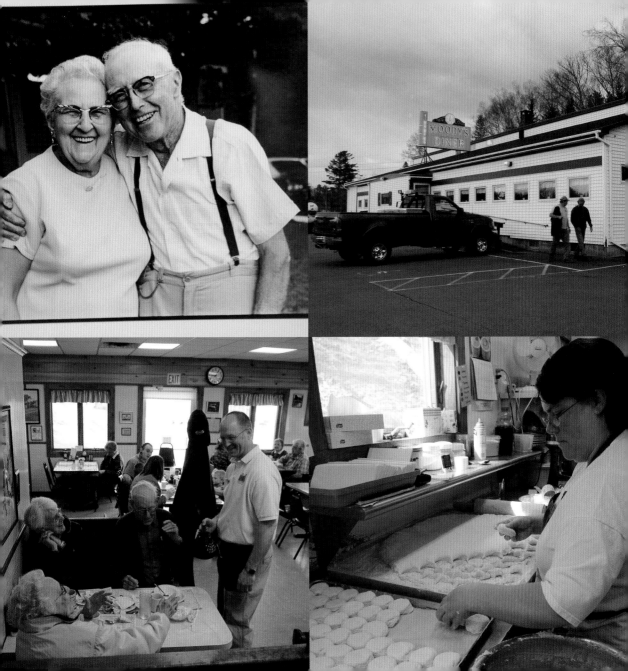

THE BEACH

California? Hawaii? Florida? Bah! Try southern Maine's "beaches region," with its 30 miles of stunning white-sand beaches. Or head on up to the less-visited Midcoast and Downeast regions for some of the finest beaches on the Atlantic coast.

Ogunquit, Algonquian for "beautiful place by the seas," offers a 3-mile-long, fine-sand stretch of heaven, with a history of visitation by artists and well-heeled summercators from the 1890s to the present. And then there's the 1.5-mile scenic coastal walk, Marginal Way, a world-class stroll that's seen its share of parasols and spats.

The Kennebunks—summer playground of former presidents Bush— have a long, rich history as a summer resort area. And the nearby 7-mile-long sand strand of Old Orchard Beach is world famous for its century-old boardwalk (the last of its type in the United States), as well as for its endearing tackiness. Just up the coast, 529-acre Popham Beach State Park in Phippsburg is a favorite family spot with grilling facilities, showers, and wildlife trails.

Off Acadia National Park's Loop Road, Sand Beach feels very Mainey. Tucked between fir-tipped cliffs, this coppery crescent beach is perfect for bodysurfing, though even the hardiest souls will find it difficult to stay in for long. Head farther Downeast and you'll find Roque Bluffs State Park, with a fine pebble beach on one side of the road and freshwater swimming on the other. Farther east sits Machiasport, home to one of the best-kept secrets on the coast—Jasper Beach, in little-known Howard Cove. In addition to its pretty location, you'll find an even prettier array of sea-smoothed stones. From there it's not far to 888-acre Cobscook Bay State Park, with its boisterous 28-foot tides; it's the new home of a mighty hydroturbine project.

If fresh water is more to your liking, Greenville's Moosehead Lake is Maine's largest inland body of water (10 miles wide and 40 miles long), with plenty of cooling options. Or try one of Maine's 2,500 other lakes and ponds. The Pine Tree State is packed with beaches—from piney to briny—so don't sweat it.

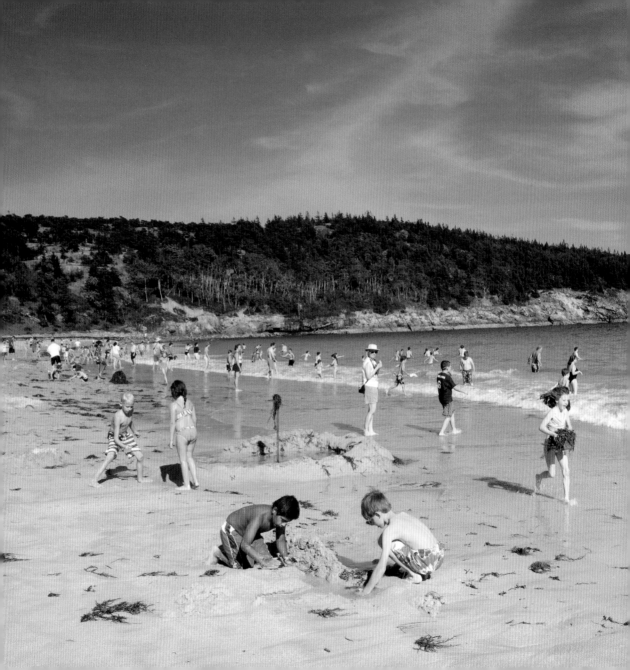

STEPHEN KING

Eerie as it sounds, it's true: One of the world's most-famous and best-selling living authors, horror master Stephen King, is also a Mainer, born in 1947 in Portland. Throughout the roughly eighty novels and 200 short stories King has written since 1974's *Carrie,* his first published novel, he has set the majority of those terrifying tales on forgotten back roads, at shorefronts, and in big and small towns all over the Pine Tree State. And dozens of film and television projects have been made based on his works, many produced in Maine.

Though King and his wife, novelist Tabitha King, in true Maine fashion tend to shy away from the spotlight, their quiet generosity has helped Maine and her people in a number of ways. They've set up the STK Foundation, a nonprofit that focuses on helping Maine communities. In addition to substantial sums given to their alma mater, the University of Maine, Orono, and to a variety of literacy projects, they've also helped local YMCA and YWCA programs and a Bangor-based swim park

Visit the king of horror at www .stephenking.com.

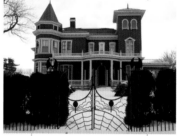

and Little League field, among others. The Kings also own three Maine radio stations. In true horrormeister fashion, one station's mascot, Doug E. Graves, is a cadaverous cartoon.

As with many a Maine man, King can often be seen sporting a beard from roughly World Series time in the fall to spring training season. He's a Boston Red Sox season ticket holder and has also been spotted in the stands at Portland Sea Dogs games.

Stephen King stays true to his Maine roots by eschewing the pretensions often associated with the rich and famous. Well, except for the massive wrought-iron gates leading to the King manse on West Broadway in Bangor. But given the man's preoccupation with all things spooky, the bat wings, dragons, and spiderwebs on those big black gates denote the man's trade, not unlike a lobsterman's stacked pots or a farmer's heifers pastured close by the front door. And they're delicious in their confirmation that, yes, this is the home of that master of horror, Stephen King.

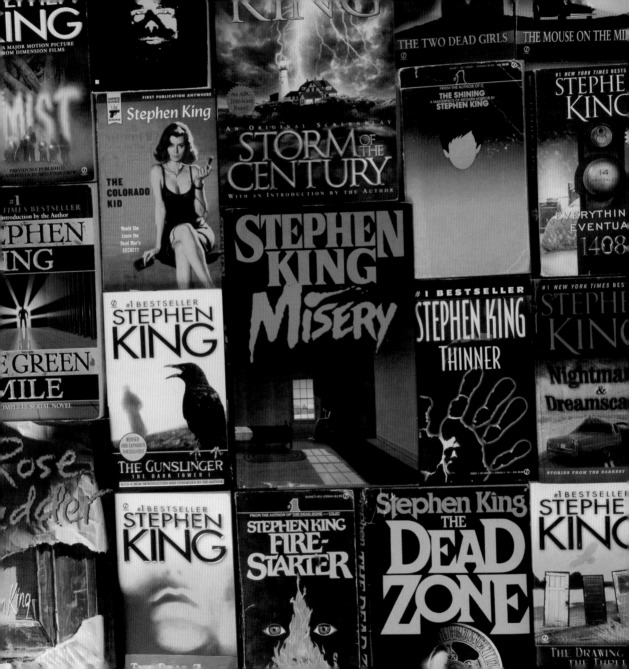

BLACKFLIES

In Germany it's a Kriebel, in Norway it's a *knott,* in Chile it's a *jerjel* . . . but in Maine we say "blackfly." Most Mainers consider these little biters even more of a nuisance than spray-happy skunks or rubbernecking tourists crawling their 45-foot RVs up Coastal Route 1 in July. So reviled are blackflies that, as with the old saw "Keep your friends close and your enemies closer," the blackfly has become something of a state mascot, and survival of blackfly season (roughly mid-May through July) is a badge of honor.

The term "black flies" was first used in New England in the late 1700s by settlers, who were greeted by dark swarms for months. In the nineteenth century's heyday of the North Woods logging camps, Maine lumbermen often shaved the hair from the sides and backs of their heads and smeared themselves with axle grease to keep the creatures from driving them mad while they felled timber.

It's difficult to comprehend how something so tiny—one-sixteenth of

Get bit at www .maineblackfly .org.

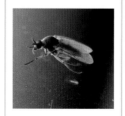

an inch at best—can cause such consternation. But it does—or rather *they* do. Because the blackflies' strength is in numbers—sometimes thousands in a swarm. And unlike mosquitoes, blackflies breed in running water. But not all of the species feed on blood, and only the females bite. Opinions vary widely about the best bug dope to use. While DEET-based products are potentially hazardous, a safer alternative is the time-honored, Maine-made tincture, 1882 Ole Time Woodsman Fly Dope.

The most common Maine method of defeating the little buggers is to use good, old-fashioned head and body nets. Drive around the state between mid-May and July and you'll quickly lose count of all the people working in their yards, tarted up in camo-green fine-mesh headgear. The next step is to make sure cuffs are tucked under socks and shirts—blackflies are not only a supreme nuisance, they are also intelligent. After all, they chose Maine. Head nets, anyone?

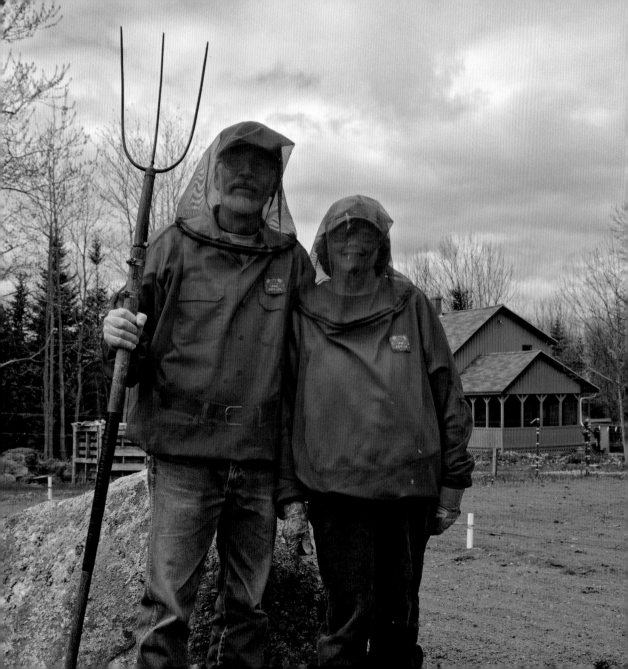

LOGGING

From its humble beginnings in the 1600s, when English sailors cut down trees on remote Monhegan Island, to 1634, when the first sawmill was built at South Berwick, to 1832 in Bangor (then the world's largest lumber shipping port, hosting 3,000 ships at once in its river harbor—nearly 9 billion board feet of lumber passed through Bangor between 1832 and 1888) to today, when paper pulp mills dot the state and much of the vast forested acreage of Maine's North Woods is owned or controlled by a handful of massive logging companies, logging in Maine has always meant big business.

Through the centuries, the Maine logging industry brought about innovation that would affect timber harvesting the world over. The most notable contribution was made by humble Maine blacksmith Joseph Peavey. In 1858 he refined the traditional cumbersome cant dog into a more effective tool, the Peavey, that's still used today. It's difficult to top the memory of those massive long-log drives of yesteryear, when riverhogs in their spiked boots rode millions of board feet of logs downriver to sawmills in Machias and Bangor—logs destined to be rendered into lumber, loaded onto Maine-built schooners, and shipped all over the world.

Today logging in Maine is a much more technological affair. But with increasingly sounder environmental practices, the massive mills of such firms as Verso Paper, Domtar, and Wausau employ thousands of Mainers statewide from harvesting through production. All manner of forest products are manufactured in Maine, including pellets for fuel, pulp for papermaking, plus plywood, lumber, firewood, and much more. The University of Maine's Advanced Engineered Wood Composites program is innovating low-cost, high-performance structural composites, blending woods and non-wood materials for use in bridges and quake-resistant structures.

Leonard's Mills:
www.leonards
mills.com

Patten
Lumbermen's
Museum:
www.lumbermens
museum.org

Maine Forest
Products Council:
www.maine
forest.org

Maine Pulp
& Paper
Association:
www.pulpand
paper.org

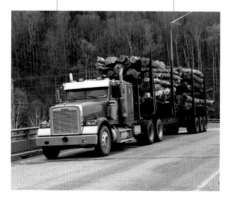

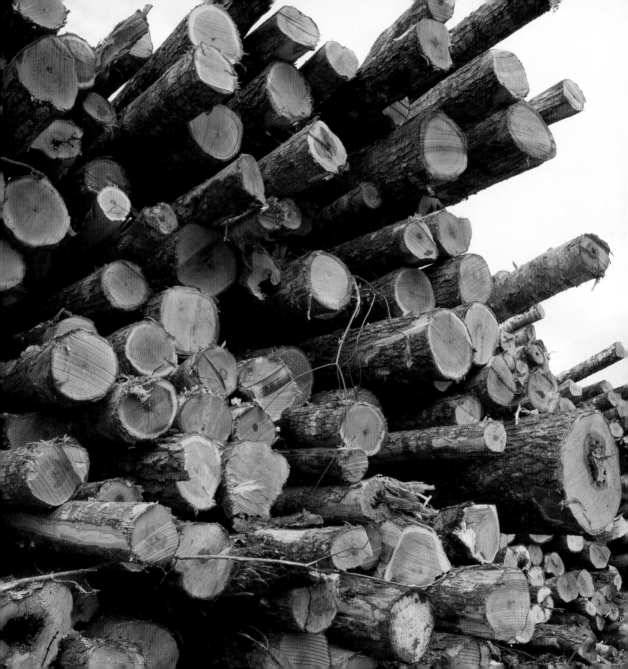

MOOSE

Of all the beasts to roam this special place we know as Maine, *Alces alces*, the mighty moose—largest member of the deer family and Maine's Official State Animal—reigns supreme. Just how supreme? An average Maine moose stands up to 7 feet at the shoulder, and their solid frames support bodies measuring more than 8 feet in length and averaging 1,600 pounds for bulls, 900 pounds for cows—a significant increase from an average birth weight of thirty-three pounds. A bull's antlers can weigh up to ninety pounds and reach 6 feet across. Maine moose enjoy a lifespan of fifteen to twenty-five years and can swim up to 6 miles per hour and lope up to 35 miles per hour on land. Nearing 30,000, Maine's moose population is second only to Alaska's.

Although moose can be found all over the state, some locales, such as the Jackman region in western Maine and Route 17 between Rangeley and Rumford, known as "moose alley," offer prime moose-watching habitat. Sadly, all these meetings of moose and people also mean that there are hundreds

The Jackman region in western Maine and the ride from Rangeley Lake to Rumford on Route 17, aka "Moose Alley," are great places to spot a bullwinkle. But go slow!

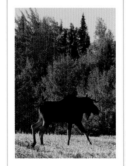

of moose–car collisions annually in Maine.

Baxter State Park is home to a variety of top viewing spots, including Sandy Stream Pond, where it seems as though the prolific beasties have become so accustomed to the presence of tourists snapping pictures that they don't pay them much attention—though one would be wrong to mistake the big creatures' indifference for tameness. They have been known to knock down, drag, and pound a grown man to death.

Every year Maine's moose hunting season—late September through late November—helps balance what would otherwise be a population boom detrimental to both Maine's moose and human populations. If you're curious, moose meat is lean and tasty. In fact, Henry David Thoreau likened it to veal.

There is one moose you might not mind colliding with: Lenny, the life-size chocolate moose, who's 8 feet tall and made of 1,700 pounds of premium-grade chocolate, can be found wading in his milk-chocolate pool at Len Libby Chocolates in Scarborough.

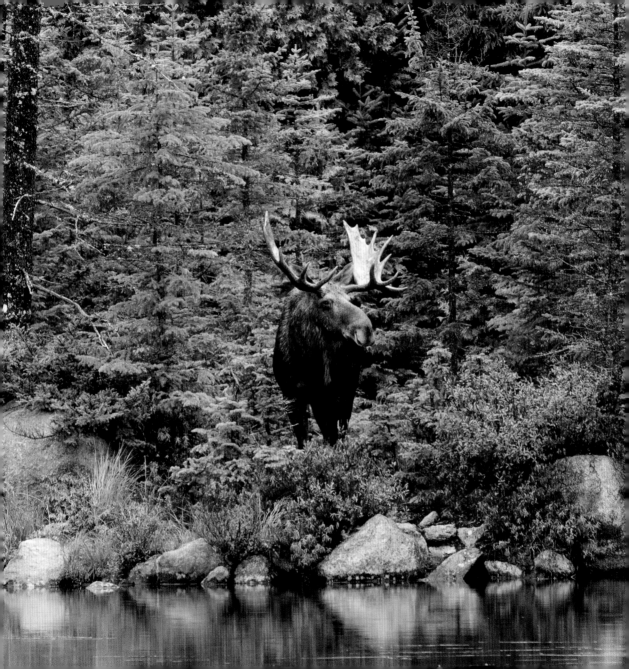

DELORME'S
MAINE ATLAS & GAZETTEER

How can you tell if someone's a true Mainer (or at least a Mainer at heart)? Take a peek at his/her car or truck seat. See a dog-eared, oversize paperback book rimmed with sky blue, duct tape lining the spine, the cover sporting a spinachlike rendering of the state of Maine topped with the words *Maine Atlas & Gazetteer*? Yep, that's a Mainer's car.

First introduced in 1976, DeLorme's ubiquitous collection of maps, or *The Gazetteer* as it's known in Maine, is not only simple to use but has pages packed to the borders with vital information for fishermen, hunters, campers, beachgoers, hikers, picnickers, and history hounds.

At 11 by 15½ inches and with a scale of 1 inch to 2 miles, it's big enough that tracking down a location is a snap. Each of the seventy topographical map pages covers an area of 29 by 21 miles. Add to that ten pages of street maps of Maine's more populous places and sixteen more pages of historical site locations, fishing, camping, and boating access points, a distance grid, a full index—and you're on your way.

Visitors can see the world, aka "Eartha," in Yarmouth at DeLorme HQ or at www.delorme .com.

If that weren't enough, a visit to DeLorme headquarters, just off I-295, exit 17, in Yarmouth, reveals . . . Eartha, the world's largest revolving, rotating globe. Unveiled in 1998 after a two-year building process, the built-to-scale 41.5-foot-diameter Eartha revolves, precisely mirroring Earth's movements, and is even tipped to 23.5 degrees on her axis—just like the real thing. Visitors can get up close and personal with Eartha by using observation platforms in her three-story glass atrium.

For more than thirty years DeLorme has led the mapping industry in innovative products and technology and it has cornered the market on useful maps of just about anywhere in the world you'd like to go (especially in Maine). Despite this global success, it's the humble *Maine Atlas & Gazetteer* that helps Mainers get around their state. In fact, the only downside to having a DeLorme's *Maine Atlas & Gazetteer* in your car is that you'll find you need a second one for the house.

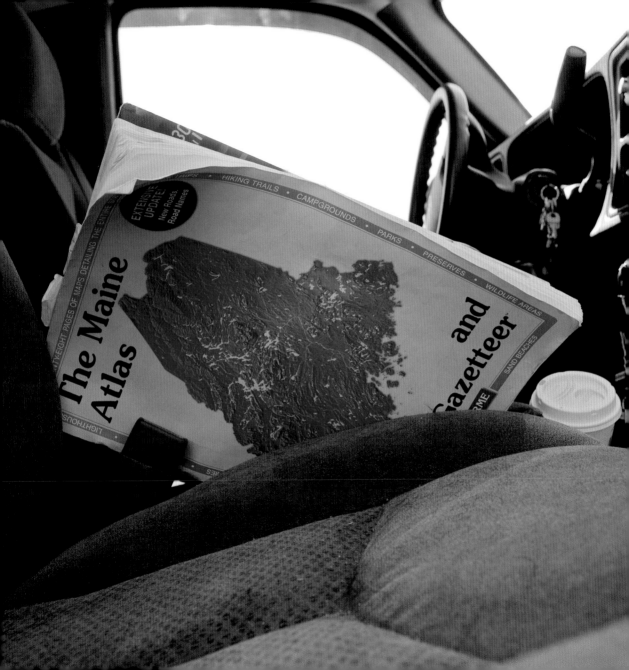

BLACK-CAPPED CHICKADEE

On a cold day in 1927, the legislature of the State of Maine adopted the black-capped chickadee as the Official Maine State Bird. Rumor says it was chosen because, like any true Mainer knows, you have to be committed enough to live here year-round. And as anyone who toughs it out in January will tell you, the chickadees, though definitely a little nutty, are most certainly here.

Poecile atricapillus averages 5 inches in length and is the most commonly sighted bird throughout the Pine Tree State, from coastal island bird feeders on inland to Sugarloaf and all points north. In fact, if the feeders run low, chickadees are not shy about letting homeowners know. Its fluttering wings are as common a sound as its distinctive *chick-a-dee-dee-dee* call. As hunters, hikers, and backyard bird enthusiasts know, with little coaxing—and perhaps a few seeds to seal the deal—the nosy little things will land on one's hand, hat brim, shoulder, boot tip, or rifle barrel.

It's almost as though the entire species has taken it upon itself to be the state's official goodwill ambassador, so seemingly seriously does it take its role as the state's official bird. In 1999 the chickadee usurped the cooked lobster (that looked to most Mainers like a red spider) on the official Maine license plate. And Mainers are fine with the change.

Black-capped chickadees thrive on a variety of foods, including insect eggs, ants, snails, and various seeds. Someone figured out that chickadees can recall for up to eight months just where they've stored food for our long winters. Much like Mainers, who employ a variety of techniques to reduce their heating bills, on winter nights chickadees curl up tight and enter a light hibernation to conserve energy. Also like Mainers, in winter it's difficult to tell the male from the female of the species. They're both capped and both hang out close by an easy food source—feeders, general stores, and diners.

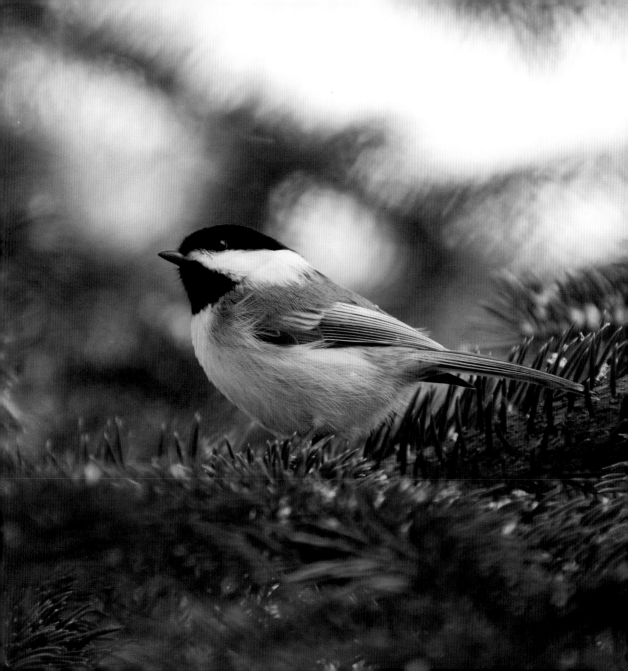

LOBSTER

With respect to the other forty-nine iconic institutions, ideas, products, people, and places in this book, it is *Homarus americanus*, the humble lobster, that is Maine's most immediately recognizable icon. And though it can be enjoyed anywhere in the world, Maine is the best place to experience lobster fresh caught, then cooked and consumed, whether it's dipped in melted butter, chilled and placed on a bun, surfed-and-turfed, or tossed lightly in mayonnaise. So revered in Maine is the lobster that 2012 marks the sixty-fifth anniversary of that annual August event, the Rockland-based Maine Lobster Festival. Run by 1,000 volunteers, the five-day celebration of all things lobster includes a parade, lobster-crate race, and more than 20,000 pounds of lobster cooked in the world's biggest lobster boiler.

In colonial times there were reports of lobster 5 to 6 feet long, though the largest lobster caught in recent times was a nearly 4-foot brute caught in 1977 in Nova Scotia. It weighed in at forty-four pounds and was estimated to have been one hundred years old (it takes an average of five to seven years for a lobster

Plan a visit to the Maine Lobster Festival at www.mainelobsterfestival.com.

to reach maturity). The largest verified lobster caught in Maine was a thirty-six-pounder. But you can bet he wasn't red—that only happens *after* they've taken a stovetop steam bath. In their natural element, lobsters are usually greenish black with an orange underside, but off-color lobsters are occasionally caught. These anomalies range from albino to mottled to orange, green, and blue.

The average size of a Maine lobster dropped from four to five pounds in 1860 to less than a half pound by 1880. By the turn of the twentieth century, conservation efforts were enacted and the fishery rebounded. Though they are trapped year-round, the tender and sweet new-shell lobsters are harvested primarily during shedding season—July through October. As luck would have it, most folks visit Maine during this season.

Today approximately eighty million pounds of lobster are pulled from Maine waters each year by 6,000 lobster harvesters, ensuring that more lobsters are harvested in Maine waters than anywhere else in the world.

So . . . got lobster? Maine does.

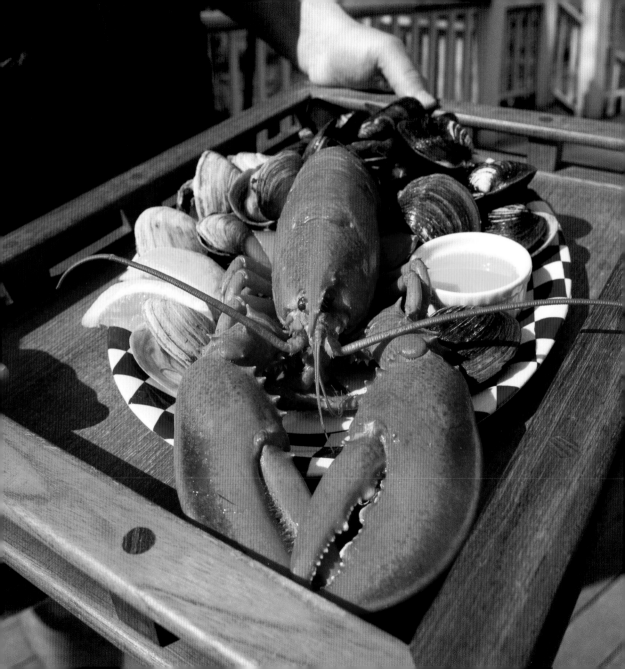

THE WYETH FAMILY

Though he divided his time between Chadds Ford, Pennsylvania, and Cushing, Maine, it is for *Christina's World*—one of his numerous Maine-based paintings—that Andrew Wyeth is most known to the masses. The painting of his Cushing neighbor Christina Olson, sprawled in a field and looking toward the stark farmhouse where she and her brother spent their lives, captures Wyeth's penchant for stark, realistic scenes conveying hidden depths of meaning.

It is impossible to talk of Andrew Wyeth in Maine without mentioning his family and its long tradition of artistry here. His father, N. C. Wyeth, noted for illustrations that enhanced classic tales such as *Treasure Island*, brought his family to spend summers at "Eight Bells," the name he gave to a weathered old Port Clyde Cape. Here N. C. and his artistic brood practiced their art and played.

Two of Andrew's sisters, Henriette and Carolyn, were also painters, and one of his sons, James (Jamie), also gained fame as a painter for, among

Wyeth Center:
www.farnsworth
museum.org
/wyeth-center

Olson House:
www.farnsworth
museum.org
/olson-house

Brandywine
River Museum:
www.brandywine
museum.org

other works, his posthumous portrait of John F. Kennedy. Much of Jamie's early Maine-based work grew out of the time he spent on Monhegan Island, where he bought the home built by painter Rockwell Kent.

N. C. and Andrew Wyeth have both passed away (N. C. in 1945, unexpectedly at the age of sixty-two, and Andrew in 2009 at age ninety-one). Jamie, now in his sixties, continues to paint and uses as a studio the Tenants Harbor Lighthouse, on Southern Island at the harbor mouth in St. George, Maine.

The Olson House, in Cushing, is open to the public and is owned and maintained by the Farnsworth Art Museum. The Rockland-based Farnsworth is the official Maine home of Wyeth family art. Close by sits the nineteenth-century United Methodist Church, transformed by the museum into the Wyeth Center, dedicated to the Wyeths and their artwork. Along with the Brandywine River Museum in Chadds Ford, it's a fitting home for America's first family of art.

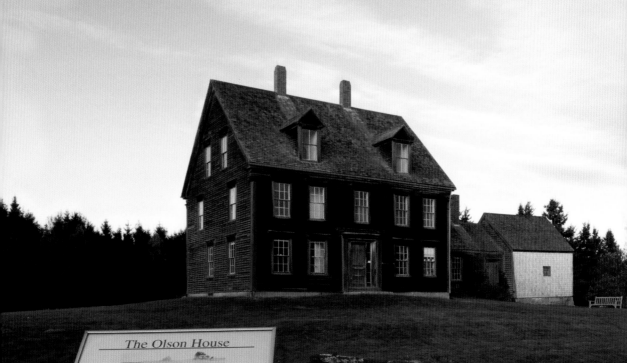

The Olson House

*Andrew Wyeth, Christina's World, 1948, tempera,
Museum of Modern Art, New York*

Formerly known as the Hathorn House, the Olson House was built
in the early 1800s and remodeled in 1871. From 1872 to the 1890s
Captain Hathorn, retired from the sea, rented rooms to summer
visitors. In 1892 John Olson married Kate Hathorn and took over
the Hathorn Farm. Two of the Olson's children, Christina (1892 -
1968) and Alvaro (1894 - 1967) lived in the house until their deaths.

The Olson House and Alvaro and Christina Olson inspired
numerous drawings, watercolors and tempera paintings by artist
Andrew Wyeth from 1939 - 1969, including the 1948 tempera,
Christina's World.

The site was donated in 1991 to the Farnsworth Art Museum
in Rockland, Maine by John and Lee Adams Sculley.

Admission charged

Please respect the rights of private property owners by restricting your visit to the museum site only.

BALSAM

Along about November 1 each year, droves of Mainers head to the woods to "do some tippin'" for extra cash for the holidays. Nope, it doesn't involve pushing over snoozing cows but rather pinching off the tips—the last foot or so—of a Maine balsam fir tree's branches. Once the weather turns cold (that's after three 20-degree-nights), Maine's balsam fir needles "set" and the tree's natural waxes prevent the needles from falling out. And since tipping is a form of pruning, this ensures the tree's continued growth and actually improves the overall quality and health of a Maine balsam fir, which, incidentally, lives for an average fifty to sixty years.

Maine's best-known balsam product is the Christmas wreath: The tips are trimmed, bundled, and wired onto metal rings; decorated with pinecones, bows, and berries; and shipped all over the world. Maine wreath makers produce tens of thousands of balsam wreaths, trees, garlands, kissing balls, centerpieces, and decorative swags each year.

The Worcester Wreath Company, located way Downeast in Harrington,

Wreaths Across America:
www.wreaths
acrossamerica.org

Worcester Wreath Company:
www.worcester
wreath.com

Paine Balsam Fir Products:
www.paine
products.com

manages its own 4,000-acre forest; its balsam is transformed into various products, including wreaths. In 1992 the company's president, Morrill Worcester, started the Arlington Wreath Project at Arlington National Cemetery to honor American veterans by donating 5,000 wreaths for their gravesites. Since then the program has been taken over by Wreaths Across America, which each December places more than 100,000 donated wreaths in Arlington and at 350 other cemeteries and monuments across the United States and overseas.

Long before wreaths became fashionable holiday house art, Native Americans used balsam fir as a medicine for coughs, sore throats, and other breathing ailments. Paine's Balsam Fir Products, of Auburn, has been in the balsam biz since 1931.

The company's top-selling items are a teensy log cabin–shaped incense burner and another big favorite, the balsam pillow. Snuffling one is almost as good as a walk in the Maine woods—almost—and is heartily recommended for those who had to leave Maine at the end of a swell vacation.

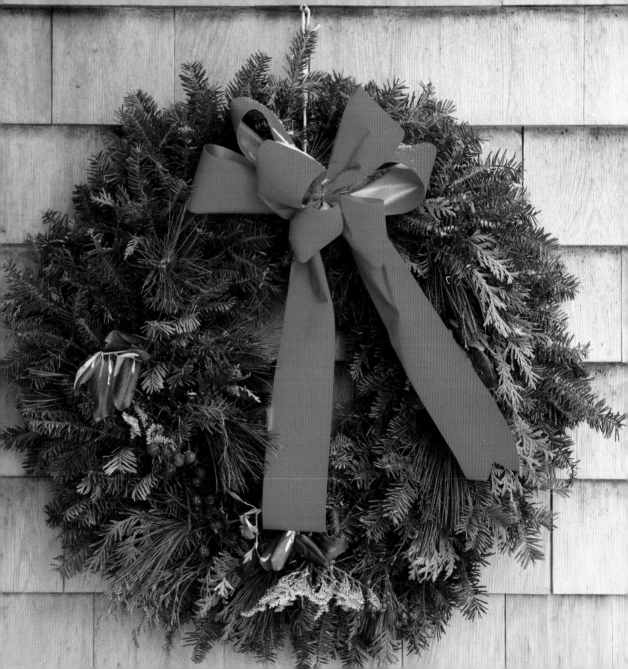

BEAN HOLE BEANS

It might be said that beans built Maine. And the remark wouldn't be far from true. For beans—in all their varied names, shapes, colors, sizes, and varieties—provided Maine woodsmen with the protein-rich fuel their bodies needed to work in the North Woods, day after frigid winter day, felling mammoth white pines.

While most people rightfully associate pit-cooked, or bean hole, beans with the late-nineteenth and early-twentieth-century age of Maine's great log drives, Maine's native people, probably the Penobscot Indians, have a long history of slow-cooking beans in pits. They filled clay pots with beans, bear grease, and maple syrup, then wrapped the pots with deerskin and baked them in rock-lined pits in the ground for many hours. Early European settlers learned the method and added their own nuances to the process, namely the use of a black-iron pot in which to cook the beans in the fire pit.

Modern bean holes don't differ much from their predecessors: 2-foot-deep pits lined with rocks. A fire is left

Maine Organic Farmers and Gardeners Association: www.mofga.org

Leonard's Mills Maine Forest and Logging Museum: www.leonards mills.com

Patten Lumbermen's Museum: www .lumbermens museum.com

to burn down in the hole, then a lidded pot filled with a favored bean (yellow-eye, Jacob's cattle, soldier, and Great Northern rate as top varieties among Mainers) is lowered into this improvised oven, where it is packed on all sides and on top with the broiling coals. The entire affair is then covered with dirt and allowed to bake overnight.

Maine's addiction to beans runs deep. The B&M plant still cans its "brick-oven baked beans," as it has in Portland since 1927. And the state buzzes year-round with "public suppahs" on behalf of local fire departments, school benefits, and grange halls; frequently the star attraction is bean hole beans.

Like to experience this slow-cooked gourmet dish for yourself? The Common Ground Fair in Unity and Leonard's Mills Maine Forest and Logging Museum in Bradley will introduce the novice bean-holer to the wonders of Maine's tastiest woods-camp tradition. And on the second Saturday of August, Patten Lumbermen's Museum, Patten, hosts its annual Bean Hole Day.

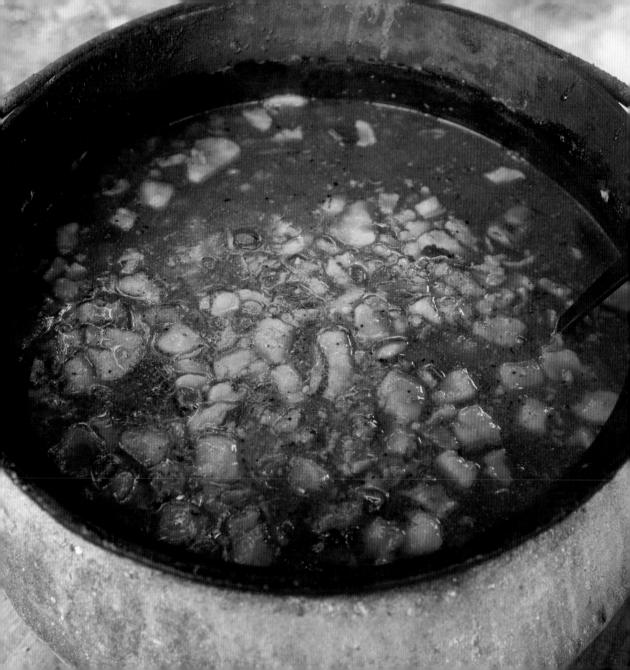

ACADIA NATIONAL PARK

In 1604 what the Abenaki called *Pemetic* ("sloping land") Samuel de Champlain named *Isle des Monts Deserts,* or "the island of bare mountains," because of the treeless hard-rock heights that lorded over the lovely harbor. Much European settlement and trading ensued, and in 1901 a handful of wealthy summer residents of tony vacation spot Bar Harbor, on Mount Desert Island, spearheaded by Harvard University president Charles W. Eliot, established a public land trust. In 1919 this became Lafayette National Park, the first national parkland east of the Mississippi River. It was renamed Acadia National Park in 1929. In addition to being New England's only national park, it is also the first national park whose land is made up entirely of private donations.

John D. Rockefeller Jr. deserves praise for donating 10,000 acres to the park's formation. He also designed, funded, and had built the 45-mile network of carriage roads and bridges of locally quarried Mount Desert pink granite that now offers access to the park for all. Eighty percent of the park's

Visit Acadia National Park online: www.nps .gov/acad

visitors use the carriage roads for walking, jogging, cycling, horseback riding, skiing, and snowshoeing.

Acadia National Park boasts eight peaks custom made for climbing, none of them technical ascents. The loftiest, Cadillac Mountain, is the highest point on the North Atlantic Seaboard. Other park attractions include the Jordan Pond House—where tea and the world's best popovers have been served since the late 1800s on the long, rolling lawn facing Jordan Pond and the hills known as the Bubbles in the distance. The scenic, 20-mile Park Loop Road leads to Thunder Hole, where slamming water from the incoming waves makes a sonic boom! Sand Beach, the ideal Maine beach, is tucked in there too, hugged by fir-topped cliffs that give it a hidden feel, and then there are those frigid Atlantic waves. . . .

The park spills off Mount Desert Island and onto Isle au Haut, and a goodly portion is located on Schoodic Peninsula, the next peninsula heading Downeast. This seldom-visited but beautiful, raw bit of the park is well worth a look.

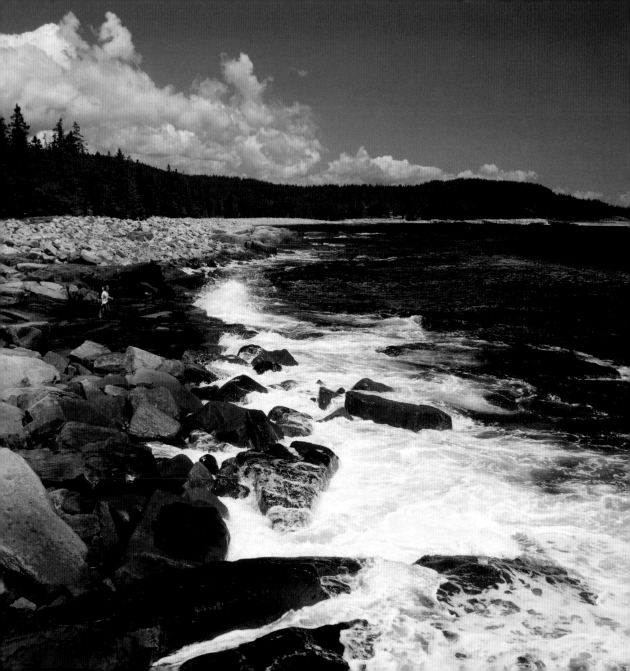

MAINE'S NATIVE TRIBES

Though various indigenous cultures have inhabited this place for roughly 11,500 years, beginning with the Paleo-Indians, modern Native Indian tribes didn't band together until the early 1700s, when they collectively became known as the Wabanaki Confederacy. Today this group comprises Maine's five federally recognized Native American tribes: the Aroostook band of Micmacs, the Houlton band of Maliseets, the Passamaquoddy tribe of Indian Township, the Passamaquoddy tribe at Pleasant Point, and the Penobscot Nation.

Despite the indignities of broken treaties, stolen lands, inadequate compensation, famine, pandemics, and war brought about by European settlers, since passage of the Maine Indian Claims Settlement Act in 1980, the tribes have fought with determination and ingenuity to maintain their cultural identities. They have been aided in their long labors by established institutions such as the University of Maine's Hudson Museum's Maine Indian Gallery, with its impressive collection of native crafts. Bar Harbor's Abbe Museum is likewise dedicated to "celebrating Maine's Native American

Abbe Museum: www.abbemuseum.org

Hudson Museum: www.umaine.edu/hudsonmuseum

Maine Indian Basketmakers Alliance: www.maineindianbaskets.org

heritage" through engaging museum exhibits and an active events calendar, including the annual Native American Festival and Basketmakers Market in July.

Of the numerous traditional native crafts, basket making has risen to a high art form among the tribes of Maine. The intricately woven vessels, in shapes such as the cone of the white pine, honoring Maine's state flower, are crafted using traditional methods and materials—the Penobscots use sweetgrass, brown ash, and birchbark—and are sought by collectors worldwide.

The state's Indian heritage is also reflected in the unique place names found throughout Maine. Katahdin, the name of the state's highest peak, means "the greatest mountain" in Penobscot; Allagash means "bark shelter" in Abenaki; and Ogunquit is a Micmac word meaning "lagoons with dunes."

The first commercial gambling operation on a U.S. Indian reservation, Penobscot High Stakes Bingo, opened in 1973 on Indian Island, Old Town. Such gambling ventures help tribes protect, sustain, and nurture the growth of their unique cultural identities.

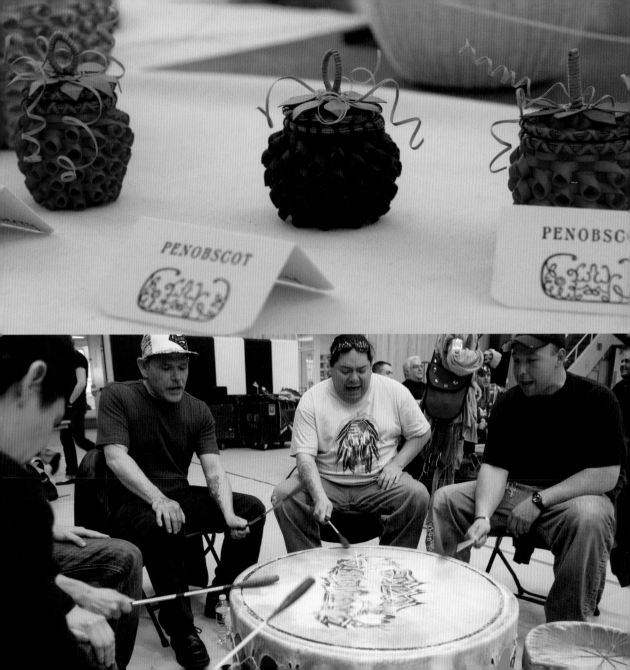

PENOBSCOT

PENOBSC-

THE MAINE GUIDE

The romantic notion of a Maine Guide is a man decked out in Bean boots, checked flannel shirt, woolen trousers, a felt crusher hat, and smoking a pipe at a campfire as he regales his "sports" with pearls of homespun wisdom. An Old Town canoe bobs gently at lake's edge a few feet away, and beyond that, widening rings indicate a teasing mammoth rainbow trout waiting to be caught. Who else but a local fellow, attuned to the rhythms of Maine's natural world, could get the city slicks out over those fish? Who, indeed, but a Maine Guide?

In truth, a Maine Guide is much more than a composite of romantic ideals. The Maine Department of Inland Fisheries and Wildlife defines its Maine Guides thusly: "'Guide' means any person who receives any form of remuneration for his services in accompanying or assisting any person in the fields, forests or on the waters or ice within the jurisdiction of the State while hunting, fishing, trapping, boating, snowmobiling or camping at a primitive camping area."

Visit Maine's guides online at www.maine guides.com and www.maine guides.org.

Ironically it was a woman, Cornelia Thurza "Fly Rod" Crosby, who became the first licensed, registered Maine Guide on March 19, 1897, when the State of Maine began requiring that all hunting guides be registered. Within that first year, 1,316 guides did so. Today 4,000 registered Maine Guides ply their trade, most as independent contractors who treat guiding as a side business.

In recent years, as traditional "blood sports" (hunting and fishing) have waned in popularity, the skill set of the Maine Guide has become more diversified. Safety, conservation, and education are as much part of the modern Maine Guide's kit bag as are paddles, fly rods, rifles, and crampons. One is as apt to find a Maine Guide whitewater kayaking or ice climbing as one is to find a hunting or fishing guide to help clients boat a lunker striper. And he—or she—just might be wearing Bean boots, a checked flannel shirt, and a felt hat.

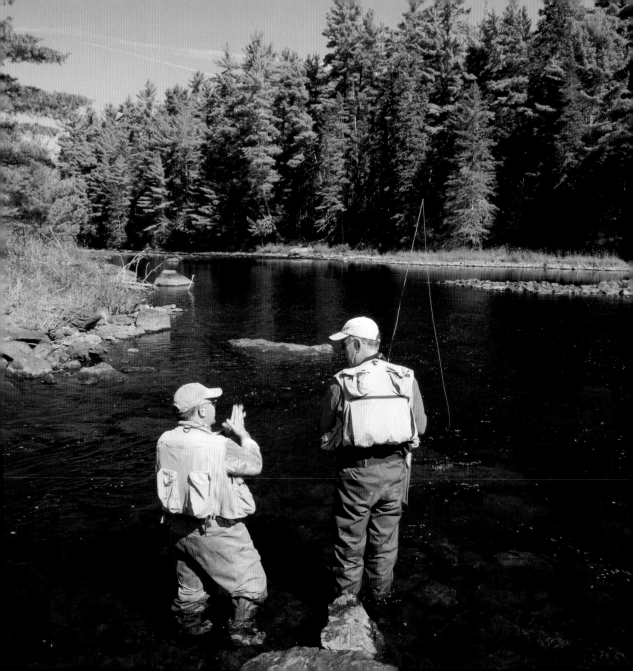

PUFFINS

Puffin, puffin, who's got the puffin? Maine does, more than we've seen in one hundred years in fact. Once hunted to near-extinction in the Gulf of Maine for their eggs, meat, and feathers, Atlantic puffins, aka "clowns of the sea" (so named because of their rainbow-colored beaks), have performed an impressive comeback in the gulf, returning to four of the six islands they once used for nesting there.

In the early twentieth century, only a single pair of puffins was found nesting south of Canada's borderline. From that pair, guarded by a lighthouse keeper intent on warding off hunters on Penobscot Bay's remote Matinicus Rock, 22 miles from shore, 150 pairs can be found nesting there today. Maine's Eastern Egg Rock hosts thirty-five pairs. (In contrast, the world's largest colony—260,000 breeding pairs—is in Newfoundland.)

Atlantic puffins, also known as common puffins and sea parrots, are members of the auk family and come

**Project Puffin:
www.project
puffin.org**

**Norton of
Jonesport
(puffin tours):
www.machias
sealisland.com**

ashore only in summer months to mate. They give birth to a single chick and then spend the remainder of their year bobbing on the North Atlantic. Demure birds, puffins average 12 inches in height, sport a wingspan of up to 24 inches, and weigh in at slightly over one pound. But these fish eaters are especially adapted to swimming and can dive as deep as 200 feet, using their webbed feet as rudders.

The puffin's once dangerously low numbers are on the rise, and the Pine Tree State has embraced this distinctive little bird with gusto. Maine is one of the few places where visitors can get up close and personal with a sea parrot on a sanctioned "Puffin Cruise" along the rocky coast. And if that weren't enough, a statewide ban on smoking in public employs the cute-clever phrase, "No puffin, please. . . ." under a rendering of a puffin, ciggie in beak, doing his best Bogey impersonation. Here's looking at you, Atlantic puffin!

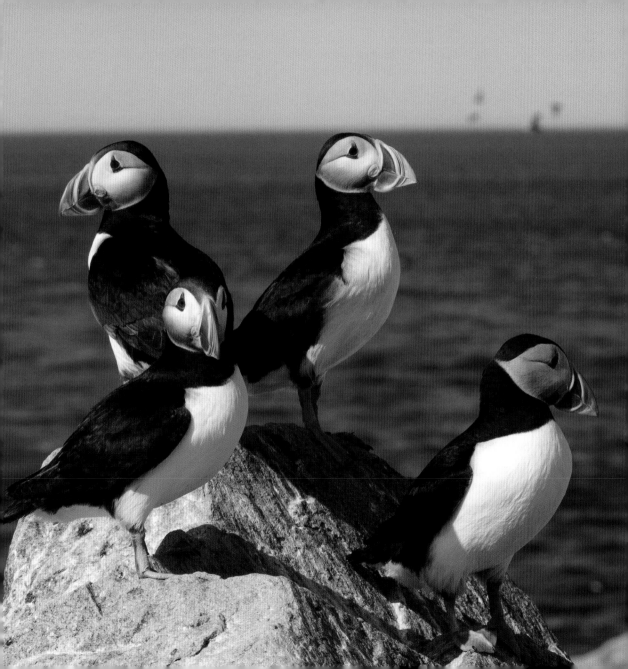

BAXTER STATE PARK

When one man has a burning desire to preserve, protect, and share with others one of the most sacred things in his life, the results can be awe inspiring. In 1930 Percival P. Baxter, Maine's governor from 1921 to 1924, wanted to share and protect for future generations a unique patch of Maine. He purchased 6,000 acres of raw wilderness in the center of the state—land that in part surrounded Maine's highest peak, 5,267-foot Mount Katahdin. He donated the land to the State of Maine, requesting only that it be kept "forever wild."

Now that's generous. But he didn't stop there: In the thirty-two years that followed, Baxter continued acquiring and donating land on behalf of the park, eventually amassing the 204,733 acres we know today as Baxter State Park. Of those acres, the 150,564 that form the heart of the park are a wildlife sanctuary where hunting and fishing are prohibited.

Baxter also left a $7 million trust to ensure the park's maintenance without putting the touch on taxpayers'

Explore Baxter State Park online: www .baxterstatepark authority.com.

purses. Today the park employs about two dozen year-round employees. That figure triples from May through October, when Baxter becomes the go-to wilderness getaway for roughly 60,000 people, some as overnighters, others as day-hikers.

In addition to Katahdin, the park contains forty-six mountain peaks and ridges, eighteen of which reach or exceed 3,000 feet in elevation. Baxter also offers 180 miles of hiking trails (including the northern end of the 2,175-mile-long Appalachian Trail), ten campgrounds, and a handful of backcountry campsites. This wild edge would suit Mr. Baxter just fine—he was quoted to say that the park should be "available for those who love nature and are willing to walk and make an effort to get close to nature."

The words of generous Percival P. Baxter say it all: "Man is born to die. His works are short-lived. Buildings crumble, monuments decay, wealth vanishes. But Katahdin in all its glory, forever shall remain the Mountain of the People of Maine."

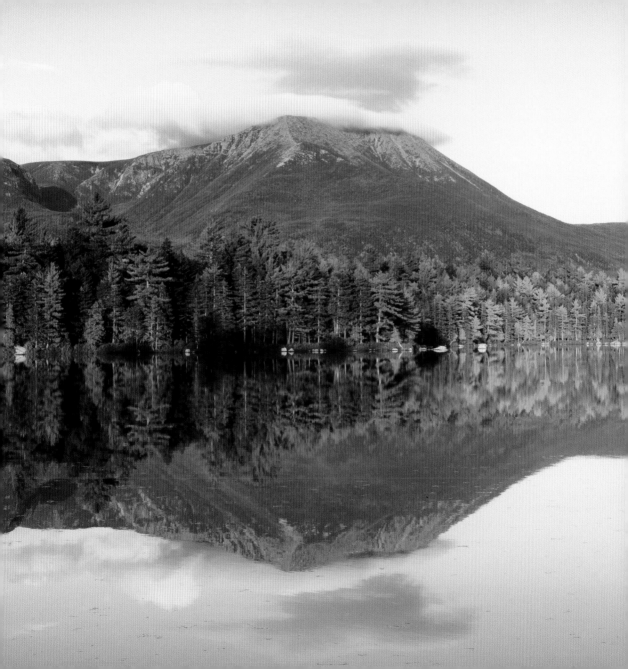

LUPINES

Like clockwork, every year in late summer, Mainers and visitors alike can be seen hopping guardrails and scrambling embankments, molesting the drying husks of lupines in hopes of gathering the flower's seeds before the pods open and scatter. But they can be forgiven, for who wouldn't want lupines *(Lupinus polyphyllus)*, Maine's unofficial state flower (that official designation goes to the white pine cone), growing in their own yard? After all, the lupine transplants well, is perfect for filling in spotty patches in yards, and is a visual stunner.

The lupine's colorful petals—like delicate, hollow slippers an inch or so long—radiate outward from a central stalk that ranges from 6 inches to 2 to 4 feet in height and bloom in colors ranging from a rich cornflower blue to a deep raspberry sherbet to buttery yellow, a variety of velvety purple hues, and even soft white. The plant's leaves are most distinctive; they resemble the spokes of a wheel, each leaf a slender, long finger

Mark your calendar for the three-day Deere Isle-Stonington Lupine Festival held each June: www.deerisle maine.com.

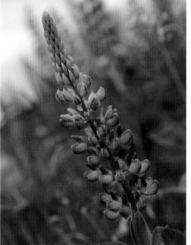

with a slight valley at its center that catches moisture. The flowers are used to dye cloth; the seeds have been known to quell a queasy stomach, help remove age spots, and contain high amounts of protein, though just because the ancient Romans ate them. . . .

Businesses all over Maine claim the rangy beauties as their mascot. One of several lupine-centric celebrations is held at Deer Isle–Stonington; these tight-knit fishing communities spin out a three-day lupine festival smack-dab in the middle of high lupine season, mid- to late June.

The State of Maine's Department of Transportation incorporates lupine seeds, along with red clover and other flowering plants, into its roadside seeding program. The results can be seen blooming in full color alongside Maine's highways throughout the summer, waving with each car full of tourists and locals whizzing by. Now that's a Maine welcome of the finest kind!

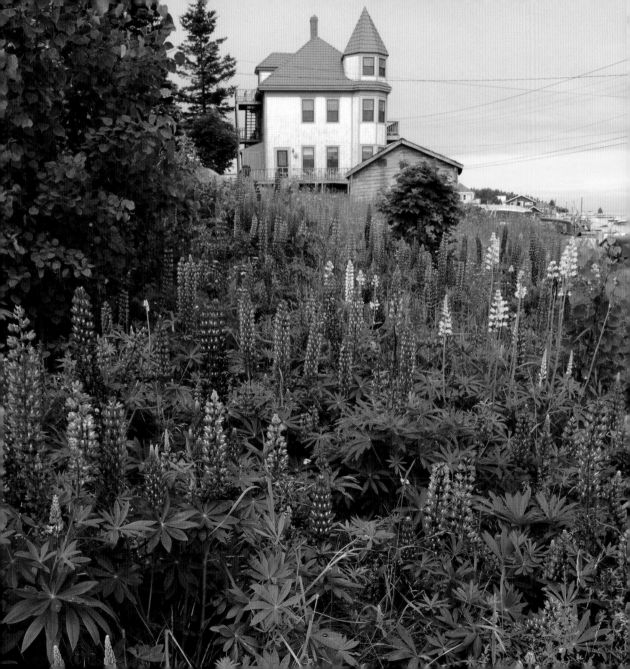

ISLANDS

Islands? Oh, yes, Maine has islands. And even for a state with an impressive 3,500-mile-long coastline, Maine's island tally is a big one: 4,613 in the Gulf of Maine alone. But Maine islands don't just exist off the coast. Many of Maine's lakes and ponds, large and small—2,500 of them—are home to at least one island (Moosehead Lake has more than eighty), even if it's just a rock big enough to kayak to and stretch out on in the sun.

There is something about being on an island that instigates a feeling of rebellion, touches on a long-buried vein of self-reliance, knowing that help—or hindrance—is not just a phone call away but also a ferry ride, at best. Year-round island communities off the southern Maine coast include Peaks Island, Chebeague, Little Diamond and Great Diamond, and the Calendar Islands of Casco Bay. Off Midcoast Maine sit Monhegan, Vinalhaven, Islesboro, Matinicus, and North Haven. Downeast has, among others, the Cranberry Isles, Isle au Haut, and Swans Island.

Maine Island Trail Association: www.mita.org

Island Institute: www.island institute.org

Maine Sea Coast Mission: www.seacoast mission.org

Monhegan, 10 miles from the mainland and perhaps Maine's most famous island, is visited daily in summer by boat and three days a week in the off-season by the mailboat. It's known as much for its robust year-round lobstering community as for the fact that so many artists claim it as muse and inspiration, hence its unofficial title as "the artists' island."

Various forms of support for year-round islanders come in part from the Island Institute, a nonprofit dedicated to helping sustain Maine's coastal communities and fifteen year-round island communities. The Maine Sea Coast Mission is a floating ministry that helps islanders with spiritual, health, and youth development. The Maine Island Trail is a 375-mile waterway stretching from New Hampshire to Machias Bay and includes more than 180 islands and mainland spots for day visits and camping. Maybe an island just big enough to stretch out on isn't such a bad idea. . . .

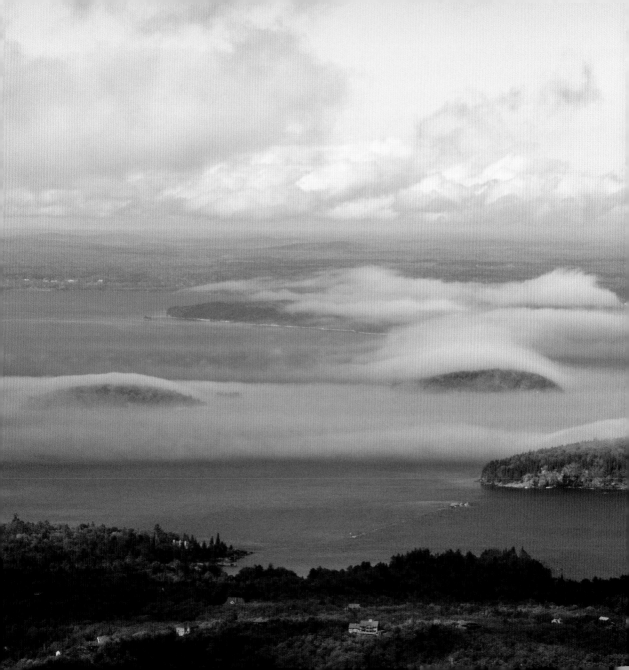

CHESTER GREENWOOD

On a fateful winter day in 1873, fifteen-year-old Chester Greenwood of Farmington, Maine, headed home, red-eared and teeth chattering after ice-skating. He asked his grandmother to sew rounds of beaver fur and cloth onto wire loops—and lo was born the humble earmuff. Greenwood patented the invention when he was nineteen, and nine years later the Chester Greenwood & Company factory, which he established in his hometown, manufactured and shipped the young man's "Champion Ear Protectors" all over the world. In 1936 the company's sales—400,000 pairs—made Farmington, among other things, the world's earmuff capital.

But Greenwood didn't stop there. He went on to patent a tea kettle, a steel-tooth rake, a matchbox sporting advertising, a shock absorber still used today as landing gear on airplanes, a type of spark plug, a doughnut hook, a folding bed, wheel bearings, and more. By the end of his days in 1937, at age seventy-nine, Chester Greenwood had racked up more than one hundred

Chester Greenwood Day: Farmington, first Saturday in December

patents on his own inventions and improvements.

In 1977 the State of Maine declared December 21—the first day of winter, naturally—as Chester Greenwood Day. And each year on the first Saturday in December, the residents of Farmington celebrate their favorite son with Chester Greenwood Day. The downtown becomes a parade ground. Guests of honor include Greenwood's descendants, and the lead float in the parade sports a Chester Greenwood lookalike in period dress, accompanied by a stand-in for Greenwood's suffragette wife, Isabel, and their four children. School buses, parade floats, babies, adults, even town dogs are all decked out in earmuffs.

Though he's best known for keeping many a Mainer's ears from freezing, Greenwood's greatest skill was his ability to figure out more efficient methods of modifying existing machinery or inventing entirely new gadgets. Perhaps that is why the Smithsonian Institution named him one of America's top fifteen outstanding inventors. Plus, he looked dashing in earmuffs.

Chester Greenwood's
Champion
Ear Protectors
For use in
Cold Weather
Patented.
...Farmington,
Maine, U.S.a

WILD BLUEBERRIES

Maine is the world's largest producer of low-bush blueberries (far tastier than the high-bush variety, which sports bigger fruit but a blander taste). Maine's wild, spiky little groundcover plants reach a height barely 6 inches off the ground, but they pack a flavor wallop that's unmatched. Maine produces 25 percent of all North American blueberries on approximately 60,020 acres, which annually require 50,000 beehives trucked in from out of state to pollinate the plants.

Mainers can tell the seasons by the color of the blueberry "barrens," vast, rock-filled reaches throughout Maine that in fall turn a vivid red, interrupted only by lumps of gray granite poking up from the craggy soil. Harvest time each August and September is known as raking the barrens, a task now largely performed by machines and migrant laborers.

If you spy a blueberry while hiking, snatch it up before a chipmunk finds it; you'll be a better person for it. Blueberries are a concentrated, action-packed powerhouse fruit that

University of Maine Cooperative Extension: www.wildblueberries.maine.edu

Machias Wild Blueberry Festival: www.machiasblueberry.com

contain nearly two dozen vitamins and minerals. They also contain antioxidants and other phytochemicals, which, among other benefits, help to combat Alzheimer's disease, inflammations, certain cancers, high blood pressure, high levels of cholesterol, and many other potentially harmful conditions.

Several Maine towns claim they are the state's blueberry capital, and a number of wild blueberry festivals take place in high berry season throughout the state. The most famous, the Machias Wild Maine Blueberry Festival, is a multiday event way Downeast complete with a parade, pie-eating contests, a blueberry-themed musical, and the 5K Blueberry Run road race. And while you're Downeast, pay a visit to the world's largest wild blueberry . . . at Wild Blueberry World, on US 1 in Columbia Falls—you can't miss it. And in Gouldsboro, also on the way Downeast, be sure to visit the Bartlett Maine Estate Winery for a bottle or three of its exquisite, award-winning Oak Dry Wild Blueberry Wine.

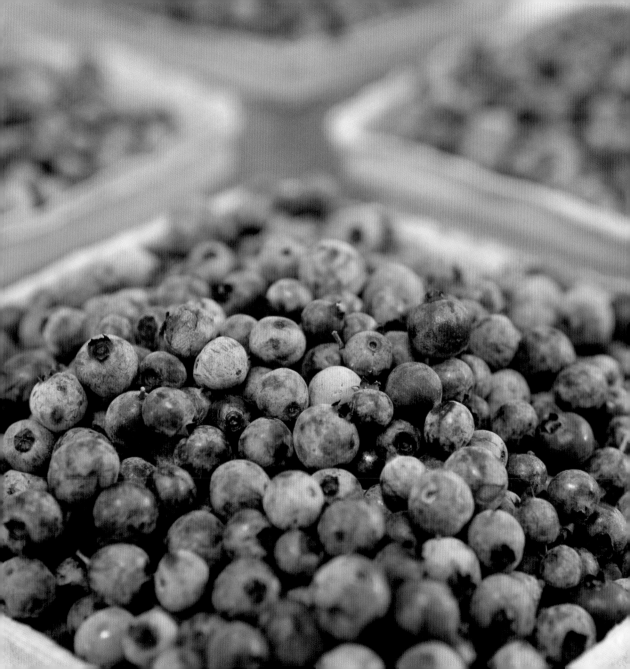

JOSHUA CHAMBERLAIN

In 1861 Bowdoin College professor Joshua Lawrence Chamberlain, fluent in ten languages, enlisted in the Union Army—with no military experience. As lieutenant colonel of the 20th Maine, Chamberlain, along with his brother, John, fought in a number of battles and skirmishes, most notably the Battle of Fredericksburg, where he distinguished himself by organizing a vital strategic defense of the hill known as Little Round Top. He was wounded twice in that battle.

In April 1864, after a bout with malaria, Chamberlain, now a brigade commander at the Siege of Petersburg, sustained a vicious wound to his right hip and groin. He managed to stay on his feet, leaning on his sword, afraid that his men would retreat if they saw him fall. He eventually collapsed from loss of blood and was expected to die. General Grant issued him a battlefield promotion to brigadier general.

But the mustachioed soldier rallied, and by November Chamberlain was

For more information about this amazing Maine man, visit the Joshua L. Chamberlain Museum at 226 Maine St., Brunswick; http://community .curtislibrary.com /chamberlain.htm.

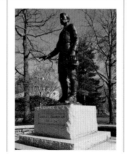

back on the battlefield. After injuries to his arm and chest, he was promoted by President Lincoln to the rank of major general. During his military career Chamberlain was involved in twenty battles and many skirmishes, received four citations for bravery, had six horses shot out from under him, and received the same number of wounds. For most men, that would have been quite enough. But Joshua Chamberlain was no ordinary man. He was a Mainer.

Following the war, Chamberlain was elected as Republican governor of Maine for four one-year terms; he then became president of Bowdoin College for twelve years. He also received the Medal of Honor for his heroic actions at Little Round Top, Gettysburg. In 1898, at the age of seventy, Chamberlain volunteered to serve in the Spanish-American War. He was rejected, and the disappointment stung him greatly. He died in 1914, fifty years after the Civil War, at the age of eighty-five—the last Civil War veteran to die of wounds sustained during the war.

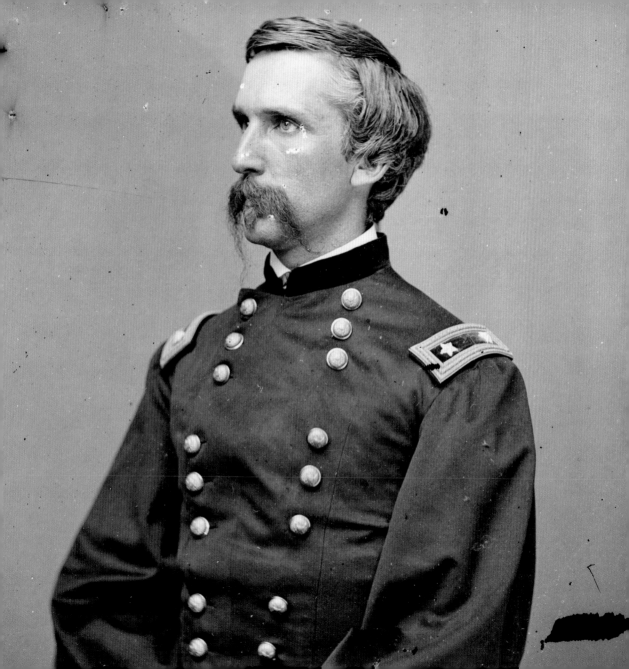

SUMMERCATORS

Dictionaries define summercator as "a temporary summer resident of Maine." The term arose after the Civil War, when tourism in Maine blossomed as an industry. In the latter half of the nineteenth century, sportsmen and artists revealed the hidden beauties of the place through paintings and tall tales. Soon their friends and families wanted to experience this refreshing, unspoiled wonderland for themselves. These early visitors were known as "rusticators," and farm families and the homes of guides served as the earliest sources of accommodation.

For those more inclined to keep their shoes clean and a drink in one hand, the term "summercator" was found most fitting. By 1880 the once-sleepy island town of Bar Harbor, on Mount Desert Island, sported thirty hotels and had become nationally known as a summer playground for the rich and well-heeled, among them the Fords, Rockefellers, and Vanderbilts. The northerly beauty of Moosehead Lake saw a brisk tourist trade as steamships ferried visitors to such tony spots as the massive Mount Kineo House,

Becoming a tourist in Maine is a simple matter; the Maine Office of Tourism at www.visitmaine .com is a great place to start.

which grew as demand for a North Woods experience increased.

The era of grand hotels slowly gave way to more affordable vacation spots for the masses, and family-oriented venues popped up all over the state—at the shore and inland at such spots as the lakes of southern and western Maine. Recent notable summercators include Julia Child, who summered here with her family for years, Katharine Hepburn, John Travolta, Martha Stewart, the (presidential) Bush family, and many others.

In a place that calls itself "Vacationland," we really can't be too put out when the summer people arrive, for they contribute mightily to the economy. Though most folks can't afford to spend weeks at a time in Maine in summer, they do still visit the state in record numbers. Just ask any shopkeeper in Boothbay, Ogunquit, or Belfast—even though Portland remains the most-visited town in Maine, especially considering its increase in cruise ship traffic, which brings in nearly $8 million per year to the Port City. Welcome to Maine!

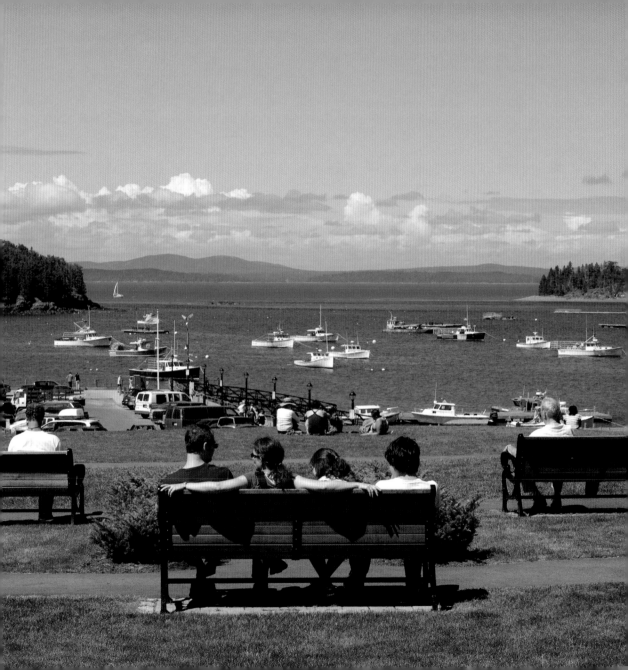

FOG

Thick as pea soup, "Thick as muthah's mustache," and "So thick you can drive in a nail and hang your hat on it"—no matter the phrase, Maine's fog is a living thing, as famous, especially among the boating set, as lobsters and blueberries. Ask any sailor or fisherman and they'll tell you that if you haven't felt your heart in your throat in a midday fog, you haven't sailed in Maine.

Technically speaking, fog comes into being when warm inland air drifts over the colder coastal water, condensing the moisture in the air. In Maine in summer, more often than not, winds from the southwest sweep coastward from inland, which seamen call a "smoky sou'wester." Way Downeast you'll see righteous fog rolling in off the Bay of Fundy. In fact, the farther one goes Downeast, the thicker the fog becomes.

In winter you're likely to witness sea smoke, a phenomenon that occurs when the air temperature is colder than the temperature of a body of water. The resulting thick, wispy fog is eerily pretty on a cold January morning. In high summer, morning fog can be thick and often portends a real scorcher once the fog burns off, usually by noontime. But if a day begins clear with a glassy look to the water close to shore and a white band of fog offshore, you can be sure that fog will roll in as the day progresses.

And being caught anywhere on the rocky Maine coast—GPS, depth-finder, and charts or no—with the fog closing in is enough to make a grown man gulp. It chills your face, speckles your eyelashes, and you can hear the bell buoy off to your port . . . or is it starboard? Yes, there's something bracing in the knowledge that you're in the act of acquiring an experience to share with family and friends. Still, discretion is the better part of valor—I'd be tempted to skip the fog and hang on the hook in a little harbor, wait it out, and hope no one's sailing too close.

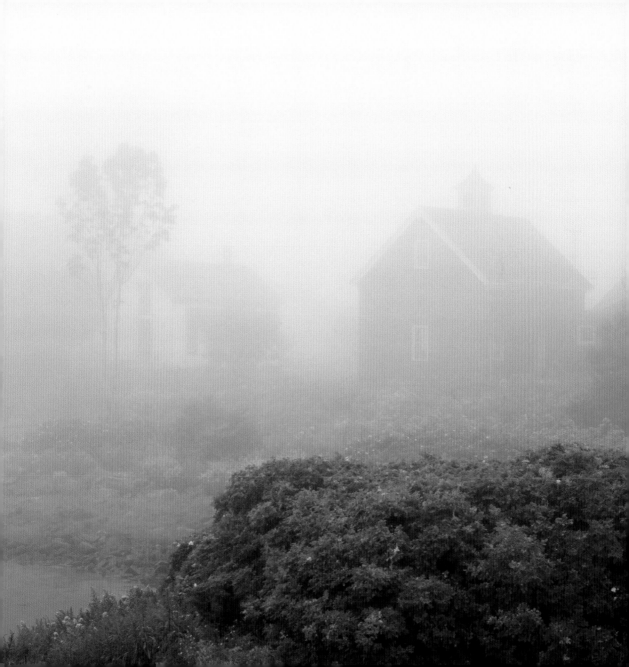

WINDJAMMERS

The coast of Maine is home to more windjammers than anywhere else in the world. And the two Midcoast towns of Camden and Rockland trade the title "Windjammer Capital of the World." Though the definitions differ little, in Maine the terms "windjammer" and "schooner" are used interchangeably, and both are equally evocative.

During the nineteenth and into the twentieth century, Maine's shipyards and coastal waters were filled with schooners, some still in use as late as the 1930s. When the age of steamers finally conquered the coast, many of these great ladies of sail were towed into harbors—Boothbay, Wiscasset, Medomak—to spend their last decades slowly rotting into the mud. A few decades later, young, enthusiastic sailors set about rescuing some of the more promising hulks, in the process renewing public interest in seeing the coast while under a whole lot of sail.

Though most of Maine's windjammers are clustered in the Midcoast region, they can be found

Maine
Windjammer
Association:
www.sailmaine
coast.com

Maine
Windjammer
Cruises:
www.mainewind
jammercruises
.com

Camden
Windjammer
Festival:
www.camden
windjammer
festival.com

up and down the coast, from Portland to Eastport. The Maine Windjammer Association is a Midcoast-based fleet of twelve vessels ranging from 46 to 132 feet on deck; seven of the ships are listed as National Historic Landmarks. One, the *Lewis R. French,* launched in 1871, is America's oldest windjammer. Each year on Labor Day weekend, thousands of schooner enthusiasts descend upon Camden for the Camden Windjammer Festival—a must-attend event with open ships, day sails, and more. No matter which harbor or which ship one chooses, a windjammer sail is time well spent, whether it's for a few hours on a sunset cruise, an overnight, or a full week out among the islands, rowing to shore for clam and lobster bakes, counting lighthouses, and watching eagles, ospreys, whales, porpoises, and seals. Don't forget singing sea chanteys, sleeping in a comfy berth, dining on home-cooked seafood and fresh blueberry muffins, sipping coffee topside, and watching the sun rise over Penobscot Bay.

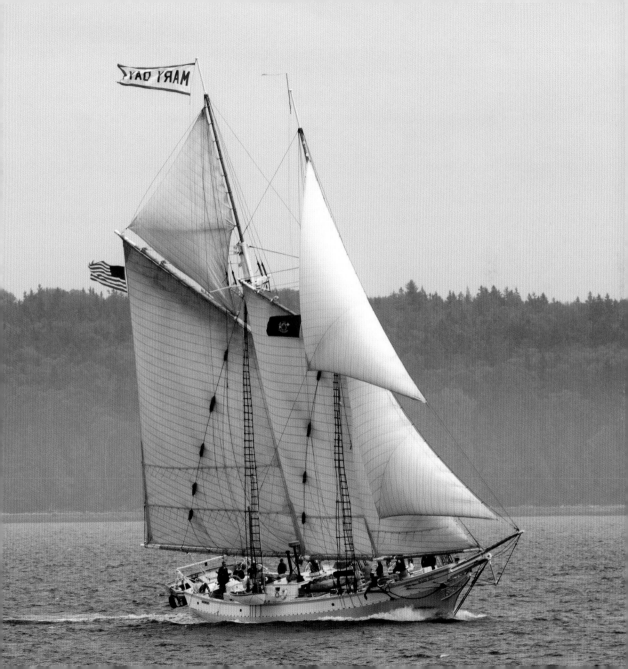

PAUL BUNYAN

Of course Bangor, Maine, is lumberjack Paul Bunyan's place of origin. After all, Maine is the cradle of the nation's logging industry. And just take a look at that manly grin—assured, confident, and so very satisfied. One can only get that way by growing up in Maine.

Maine's official Paul Bunyan statue is incredibly detailed for a hulking steel behemoth sheathed in fiberglass. At 31 feet tall (37 with his granite pedestal), Paul weighs in at an impressive 3,200 pounds—must be all those hearty logging camp meals of bean hole beans and biscuits. From those spiked boots to his sporty striped socks, green wool trousers, and black-and-red-checked coat to that mannish ruff of beard and flowing mustache, on up to the striped toque topper, Bunyan is a man's man—and a powerful symbol to represent the Queen City and its proud lumbering legacy. And if his manly presence isn't enough to convince you, consider that double-bit ax resting jauntily on his right shoulder and that massive peavey ready to

Big Paul Bunyan is always up for a visit at Bass Park, 519 Main St., Bangor. And if you're in Rumford, say hello to "Small Paul" and his blue ox, Babe.

turn the biggest log the North Woods can offer up.

The burly logger was birthed in Bangor on February 13, 1834. His life-size likeness was donated to Bangor on February 25, 1959, on the occasion of her 125th anniversary of incorporation as a city. Local man J. Norman Martin designed the Bunyan statue (and was paid $137 for the task), and Big Paul was constructed by New York–based builders Messmoor & Damon.

In February 2084, a copper time capsule ensconced in his rocky base is set to be opened on the occasion of the City of Bangor's 250th birthday. Something tells me the capsule is well protected until then.

We mustn't forget the 18-foot "Small Paul" in Rumford, overlooking mighty Penacook Falls—with a drop of 180 feet, it's the tallest waterfall east of Niagara, a fitting place for this mighty man. And just a few blocks across town—that's two strides in Bunyan speak—stands Paul's trusty sidekick, Babe the Blue Ox.

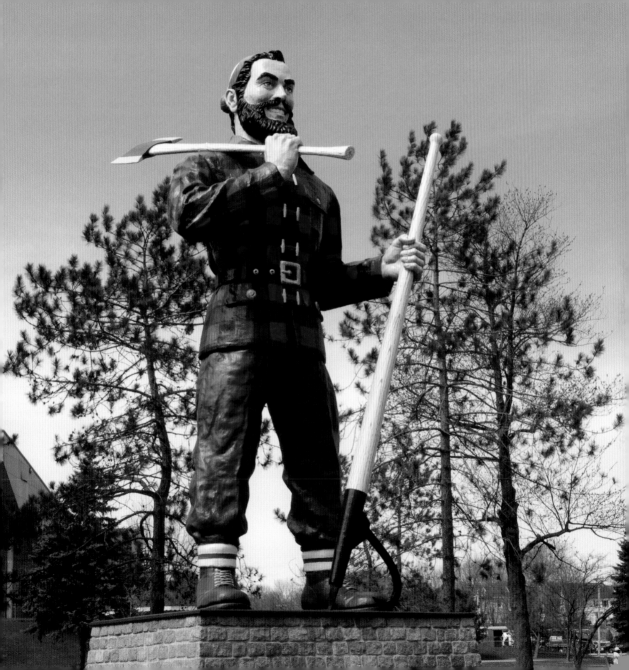

LOBSTERMEN

Of all Maine occupations, lobsterman ranks at the top of the list, romantically speaking, anyway. Lobstering can be a physically, emotionally, and financially draining occupation. But before we break out the violins, most lobstermen—a misnomer, as there are also quite a few women lobstering these days in Maine—will tell you it's a lifestyle they choose because they value self-reliance and independence. They can set their own hours, be their own boss—and listen to loud classic rock early in the morning while landlubbers are still snoozing.

Lobstering has fundamentally changed little in the century and a half since it became a commercially viable way to earn money. At one time, lobsters were gathered from shore. In the early nineteenth century, Maine men put to the sea in open dories, sinking and retrieving their homemade wooden traps. In 1820 lobster smacks came into play—sailboats with tanks in the middle of the hold with holes that allowed seawater to flow through, keeping the lobsters fresh for hungry diners in New York and Boston

Maine Lobster Boat Racing: www.lobsterboatracing.com

Maine Lobstermen's Association: www.mainelobstermen.org

and expanding the market range of the product. By century's end, there were nearly 3,000 people lobstering in Maine waters. In 2010 there were 6,000.

As with big-city gangs, lobstermen are proprietary about their territories and are generally suspicious of outsiders. Various Maine lobstering communities are known for aggressive behavior toward interloping lobstermen, from cut traplines to garbage dumped aboard boats, gunshots exchanged across bows—or worse! And speaking of boats, a lobsterman's vessel is his pride and joy. So much so that during summer, they race the diesel-driven brutes at nine serious events held up and down the Maine coast, from Boothbay to Winter Harbor, June through August.

In recent years, a handful of lobstermen along the coast also double as tour-boat operators, ferrying small groups of the curious out on lobstering trips, where they learn the details of the job, from pulling traps to bagging bait. It's a good way to get a feel for the lobstering lifestyle—if only for an hour or two.

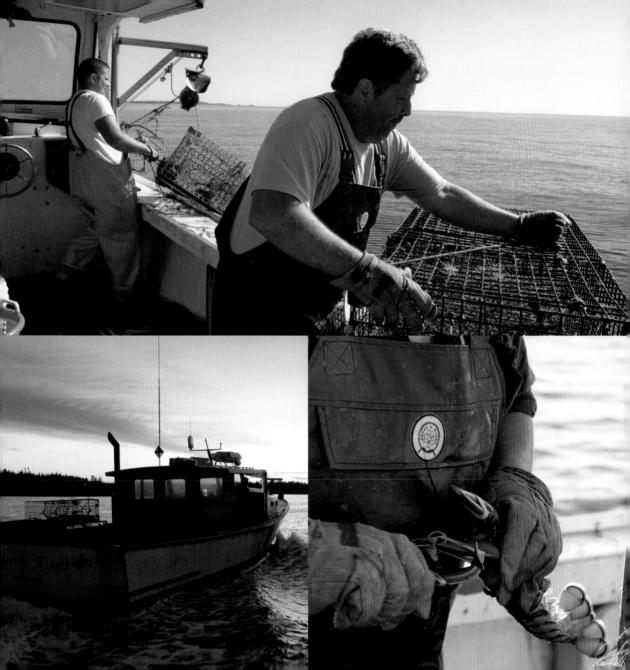

RENY'S

Its slogan is "It's a Maine Adventure!" and few people familiar with the ubiquitous logo sported on fourteen stores across Maine would argue. The adventure began in 1949, when Robert H. (R. H.) Reny peddled discount goods in his first store, in Damariscotta. But business was painfully slow, so R. H. loaded the trunk of his Hudson with goods and sold door to door. He must have been persuasive, for the customers of that first hard winter were so impressed with this young man and his affordable sundries that come spring they streamed into his Damariscotta storefront. Since then his empire has expanded. Today Reny's fourteen locations—plus the company's headquarters and warehouse and distribution center in Newcastle—employ 475 people who genuinely love working for the family-run business.

Though R. H. passed away in 2009 at the age of eighty-three, Reny's is still very much a Maine family owned and operated venture, currently run by two of his sons, John and Bob, and assisted

With fourteen locations statewide, you won't have to go far for a Reny's experience. www.renys.com

by Bob's wife, Mary Kate, plus other family members. Part of Reny's appeal is that it's by and for Mainers. In fact, most Mainers regard Reny's as Maine's homegrown Wal-Mart. Only better. Where else can you find an aisle full of Maine-made foods at Maine-wallet prices? Or discount party supplies for a beat-the-winter-blues tiki fest? And who else carries genuine felt crusher hats just like the old-time Maine woodsmen used to wear? Or yarn for knitting? Toys galore? Pillows? Pots and pans? Cosmetics and a wider assortment of toiletries than any well-stocked druggist carries? Boots, hats, gloves, ski suits, work clothes, bandannas, snack foods, sleds, garden tools, snow shovels. . . .

Perhaps the best part of any Reny's experience is an encounter with one of the Reny's ladies in their blue or green aprons. You'll get a friendly greeting and a guided tour to the exact item you were looking for—or something that will do just as well. And remember that other wise slogan: "If Reny's doesn't have it, you don't need it."

KENDUSKEAG STREAM CANOE RACE

Kenduskeag, a word attributed to the Penobscot Indians, means "place where eels gather." But every year since 1967, on a Saturday in mid-April, the fish share their water with hundreds of canoes, kayaks, and costumed cruisers participating in the annual Kenduskeag Stream Canoe Race. The largest paddling event held in New England and one of the largest in the nation, the race involves participants of all genders, ages, and skill levels in twenty-four classes.

Since that first year, when thirty-four people participated, more than 30,000 people have run the race, with record highs of 1,500 people per race in the mid-1990s—all this without corporate sponsorship. Oversight is managed by the Bangor Parks & Recreation Department, which must know what it's doing—2011 marks the race's forty-fourth year.

The 16.5-mile course can be grueling at times, and in addition to all those racers, it attracts hundreds of "River Vultures," as the spectators are called, because they perch streamside and wait for the inevitable wrecks—and

This forty-four-year-old event shows no sign of easing up! www.kenduskeag streamcanoerace .com

thus, ample photo ops. Though mandatory portages help paddlers skirt the Class IV rapids, one stretch where dumpings occur with regularity is Six Mile Falls, a Class III rapid that on race day will be lined with spectators, newspaper reporters, and TV and radio crews. Then there's the Washing Machine. And the hole known as the Shopping Cart. . . . But the lion's share of the course is a 10-mile stretch of flat water where the racers grit their collective teeth, dig in, and lunge forward in a neck-and-neck battle to gain ground, er, water.

The race has come a long way since its early days, though people still uphold a tradition of experimentation: Since the early 1970s, University of Maine engineering students have participated using specially built concrete canoes. Other notable participants include perennial favorites Team Gumby, with its larger-than-life inflatable mascot bobbing in time with each rapid, and Zip Kellogg, the dapper, white-suited racer whose canoe sports bouquets of flowers and who races every year—on his feet the entire time. Now that's a longstanding tradition.

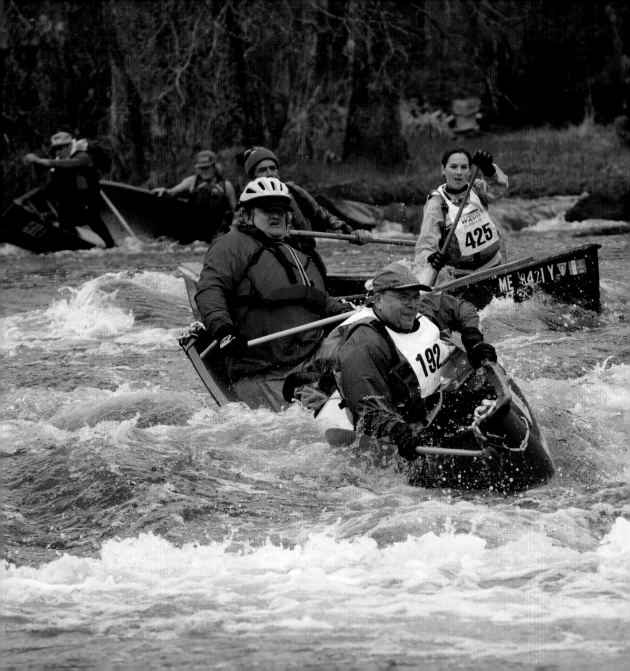

BIG CHICKEN BARN

When a rainy day lands smack-dab in the middle of a vacation, those in the know head up Coastal Route 1. Half-way between Bucksport and Ellsworth sits the Big Chicken Barn, literally a *big chicken barn,* one of dozens of such architectural remnants scattered about Maine from the days before Maine's poultry industry flew south. Many have been torn down; others sit unused, slowly collapsing. But in 1986 Mike and Annegret Cukierski recognized a business opportunity: Why not fill one of those big barns with the two things Mainers seem to never run out of—books and antiques? A quarter century later, the Big Chicken Barn—a reconditioned 21,600-square-foot barn bursting with culch, tchotchkes, furniture, books, and more—with the help of son Chad, is now run by two generations of Cukierskis (and a third is moving up in the ranks).

The downstairs houses dozens of vendor booths filled to brimming with crystal, vintage clothing, paintings, tools, needlework, antique dressers, lighting fixtures, *Happy Days* picture puzzles, a rare Morris chair, Roy Rogers 78s, and

You don't have to be a book lover to find a treasure at the Big Chicken Barn: www.big chickenbarn.com.

Neil Diamond eight-tracks. You'll also find a room full of books by Maine authors, two indoor restrooms, and a front desk peopled with helpful staffers who will gladly lend a hand in lugging that Louis XV chair, vintage lobster trap, and pair of blueberry rakes out to your Mazda Miata. (How you get it back to Baltimore is *your* problem.)

Upstairs is where you'll find 150,000-plus books (paperbacks, hardcovers, rares, firsts), vintage maps, prints, magazines, posters, brochures, broadsides, and more. It's ephemera overload, and you're invited. Got a hankering to read a pulse-pounding Western? Take your pick. Ditto for mysteries, thrillers, romances, men's adventure, kids' books, poetry, drama, nautical, travel, cookbooks, history tomes . . . and more than 20,000 magazines (plus 15,000 copies of *Life* magazine in storage!). And be sure to stop in for a gratis pick-me-up cup of java in the Coop, the upstairs coffee lounge.

The Big Chicken Barn is Maine's biggest and most original antiques–bookstore experience, where browsing is mandatory—and easily half the fun.

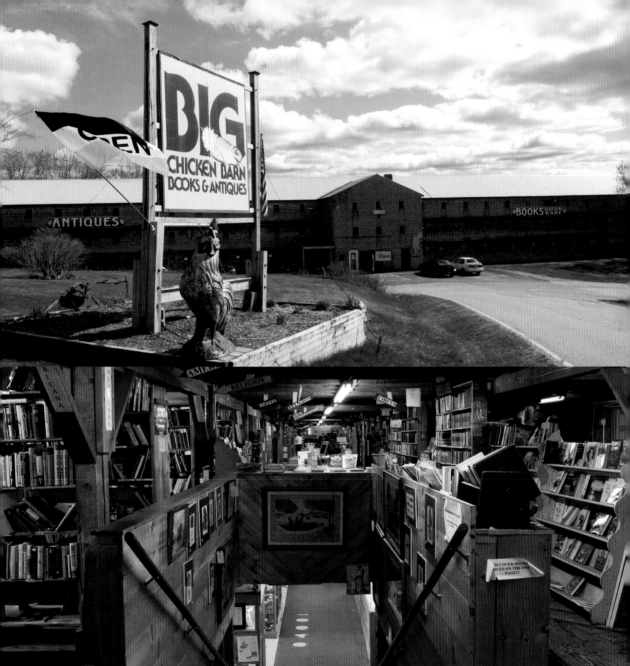

PENOBSCOT NARROWS BRIDGE AND OBSERVATORY

Since the Penobscot Narrows Bridge and Observatory officially opened in May 2007, thousands of people have ridden 420 feet up this tallest public bridge-observatory in the world in the fastest elevator in northern New England—50 feet per second, for a total ride time of fifty seconds. But that's not the top: A few more stairs will take viewers up to the first of three fully glassed viewing decks that allow for 360-degree views up and down the famed Penobscot River. At 437 feet, the top viewing deck is the height of a forty-three-story building. The very peak of the tower tops out at 447 feet; from bridge deck to the surface of the rolling Penobscot, it's a 135-foot drop. Despite the fact that the structure is super safe, a stiff breeze can make most folks yearn for a bit of terra firma beneath their Tevas.

The new bridge opened for traffic on December 30, 2006, after a three-year construction period, little time considering it was a rush job: forty-two months from conception to completion. The 2,120-foot-long span weighs 126

This stunning structure can be seen live online via webcam at www.maine.gov /doc/parks /parksinfo /observatory.

million pounds and cost $85 million. Innovative construction features of this unique cable-stayed bridge include the use of epoxy-coated steel strands inside tubing, nitrogen gas to protect against corrosion, and easy removal of individual strands for inspection.

Though the bridge itself is open year-round and is currently toll-free, the observation tower is open from May 1 through Halloween. There is a nominal fee to ascend, which includes entry into the adjacent Fort Knox; entrance to the tower is gained through the fort's check-in office.

Waist-height maps inside the tower detail what you're seeing in each direction. Just beside the new bridge sits the original Waldo-Hancock Bridge, built in 1931, which will remain for the foreseeable future; removal costs are prohibitive at present. Its lofty superstructure has, however, become an ideal home for the local osprey and peregrine falcon populations. Keep an eye out for large birds—which may be staring at the tall tower with people inside.

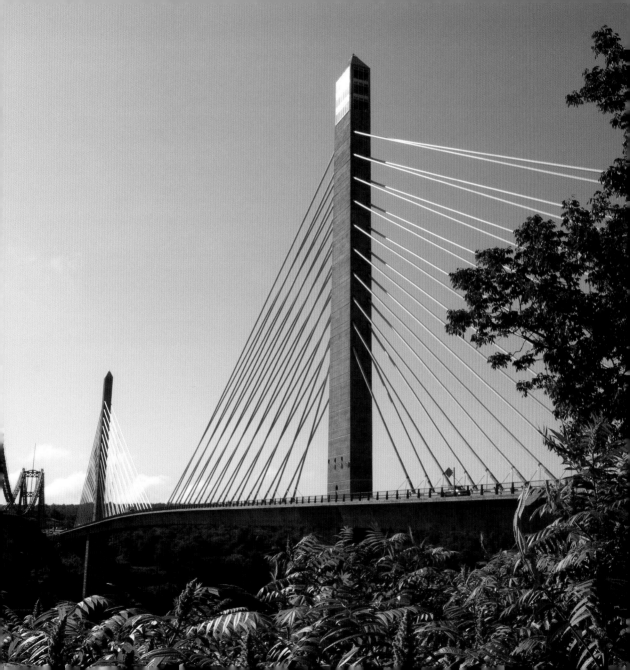

FORT KNOX STATE PARK

Of all Maine's historic military fortifications, Fort Knox, on the Penobscot River in Prospect, is the largest and most famous. Sited at the base of the new Penobscot Narrows Bridge and Observatory, the fort is also the best-preserved Civil War–era fort in the United States. It's also New England's finest example of an unmodified coastal granite fortification from the mid-nineteenth century. The fort owes much of its acclaim and fine state of repair to the fact that it saw no military action.

In 1838, as tensions between the United States and the United Kingdom escalated due to Canadian border disagreements in northern Maine's smoldering Aroostook War, the United States felt it necessary to defend the Penobscot River. The river was the state's primary artery for transporting the massive flow of lumber from Bangor—lumber that was particularly valuable in the shipbuilding trade.

The fort is named for America's first secretary of War, Maj. Gen. Henry Knox. Prior to its construction, which

History is alive and well-kept at Fort Knox State Park: www.fortknox .maineguide.com.

began in 1844, forts in Maine were built of wood. But here locally quarried granite was ferried from 5 miles upriver at Mount Waldo in Frankfort. Manned from 1863 through 1866, the fort's troops primarily comprised volunteers undergoing training before being sent to active duty in the Civil War, among them members of the famed 20th Maine. Later, Connecticut troops manned the fort in 1898 during the Spanish-American War.

In 1923 the federal government sold the fort as excess property to the State of Maine for $2,121. The fort sat neglected for decades until the nonprofit Friends of Fort Knox was formed in recent years to help prevent further decay. Today the group's preservation efforts are enjoyed each year by thousands of visitors who experience a full roster of events. Even on quiet days, the fort gets its share of folks touching the fitted stones and old cannons, peering out over the battlements, and experiencing a fine example of Maine's living history.

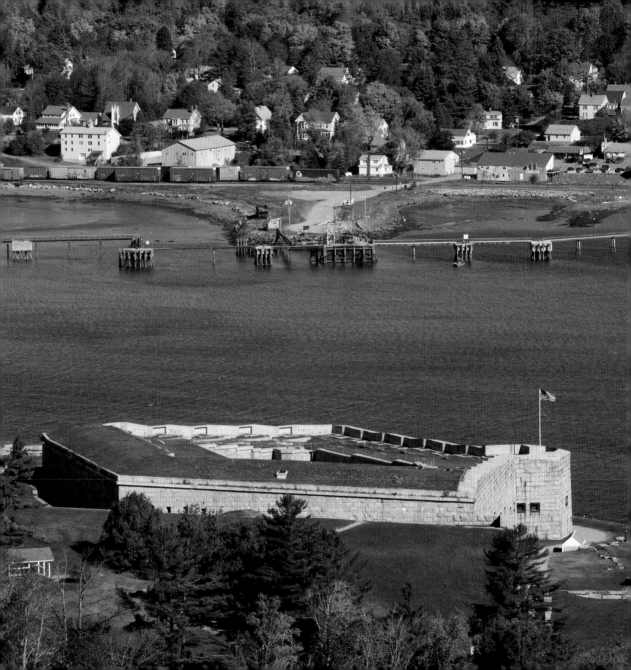

DOWN EAST MAGAZINE

In 1954 Mainer Duane Doolittle, with the help of his formidable wife, Hilda, borrowed a nautical reference that had come to designate northeastern New England and the Canadian Maritimes in general, and Maine in particular, and started *Down East* magazine on their kitchen table in Camden. Modeled stylistically on *The New Yorker*, *Down East* debuted with the August 1954 issue. The two-color cover sported a black-and-white woodcut print of a Maine fishing village, a bright red bar across the bottom, and a bold blue bar behind the all-white logo—the same hand-drawn logo the magazine sports today. And the cover price? Twenty-five cents. Since then, *Down East, the Magazine of Maine,* continues to be the arbiter of all things Maine.

From those humble beginnings to today's 105,000-plus subscribers from all over the world, the magazine has become more sophisticated. Yet despite all the changes and growth, *Down East* has stayed true to its subject matter

Visit Down East, the magazine of Maine, *online at www.downeast.com.*

and continues to be the resource readers worldwide turn to when they want information about the Pine Tree State. Not satisfied with covering the state in print, *Down East* now offers an impressive Web site for all things Maine.

Today the company, owned by the Fernald family, employs several dozen people and is housed in Roxmont, a one-time summer estate, on US 1 in Rockport. Down East Books was added to the company roster in 1977 and to date has published roughly 1,000 books on Maine. Two other magazines are also produced on the premises: *Shooting Sportsman*, a magazine of wing-shooting and fine guns, and *Fly Rod & Reel,* for the fly-fishing aficionado.

Though today Down East Enterprise, Inc., bills itself as "a multi-media company delivering authoritative and entertaining information about all things Maine," it's still run *by* people who love Maine *for* people who love Maine—pretty much what the company began as nearly sixty years ago at that little kitchen table in Camden.

RAYE'S MUSTARD

In 1900 in Eastport, the easternmost city in the United States, twenty-year-old sea captain's son J. Wesley Raye converted the family smokehouse into a makeshift mustard mill to manufacture sauces for the booming local sardine industry. Three years later, Raye moved his burgeoning business to bigger digs in town, close by a rail line for ease in bringing in raw materials and in shipping out the crated finished product. The canneries are all gone, as is the rail line, but Raye's Mustard is still there in the same spot, in the same building, using the same techniques and the same equipment. In fact, while all other mustards in the United States are either cooked or ground by high-speed means, Raye's sticks with the tried-and-true and still uses a mustard-making process developed in the 1600s—slow, cold-grinding using millstones, followed by a month-long aging and fermentation process in barrels. This makes Raye's Mustard the last traditional stone-ground mustard mill in the United States.

Still in the family, today the mill is owned and operated by a

Raye's Mustard Mill, cafe, and shop welcomes visitors at 83 Washington St., Eastport. Call Raye's at (800) 853-1903 or visit online at www .rayesmustard .com.

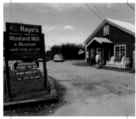

fourth-generation Raye, Kevin, and his wife, Karen, who have taken advantage of modern technology (the Web, Facebook, and Twitter) to heighten the profile of the mustard well beyond Maine's borders—and it's working: Raye's Mustard has been featured on various TV shows (including *The Martha Stewart Show*) and has won more than forty national and international awards. The mill itself, a working museum, is open year-round; visitors are encouraged to tour, ask questions, and browse the Maine-made goods in Raye's Mustard Cafe and Shop.

The line has expanded from one flavor in 1900 to twenty-five flavors today, including such tantalizing tastes as Moose-a-maquoddy Molasses, Dundicott Hot, Top Dog, White Lightnin', and Lemon Pepper. But the original Raye's Mustard flavor, Down East Schooner, is Maine's all-time, hands-down favorite—and for good reason: It's simply the best yellow mustard ever made. It comes in four sizes: four, nine, and sixty-four ounces, and one gallon.

You know you're a Mainer if . . .

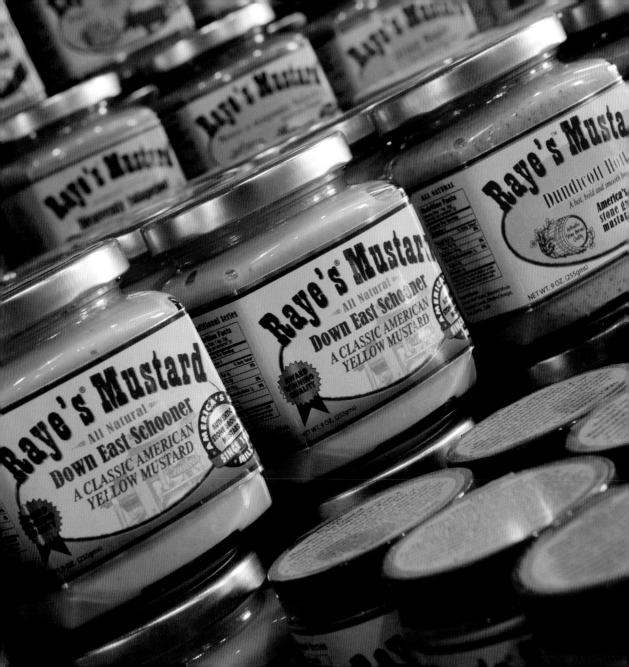

SNOWMOBILING

Since people first wintered here thousands of years ago, they have created ways of getting out and about in snow that gets pretty deep as winter progresses. It was only a matter of time before some inventive individual conjured a track-driven, ski-steered snow machine. And in the early 1900s someone did, though today's snowmobiles bear no more resemblance to their early predecessors than do Ferraris to Model Ts.

Snowmobiling as a motor sport in Maine has increased in popularity. In recent years 100,000 people have hit the state's Interconnected Trail System (ITS): 13,500 miles of snowmobile trails throughout Maine. The ITS is maintained year-round by volunteers, members of nearly 300 Maine Snowmobile Association (MSA) affiliated clubs, and their tasks include marking, grooming, trimming, building bridges, repairing washouts, and more. But these people do it because they are passionate about their sport. The Northern Timber Cruisers Snowmobile Club in Millinocket holds monthly meetings at its clubhouse, which is right next door to its

Maine Snowmobile Association:
www.mesnow.com

Sled Maine:
www.sledmaine.com

Northern Timber Cruisers Snowmobile Club:
www.millinocket-maine.net

museum filled with thirty-six antique sleds.

Throughout the winter, clubs all over the state host ride-ins, such as the Rangeley Lakes Snowmobile Club's Snodeo, an annual event that brings in professional racers and trick riders to perform for crowds. But of all the places in Maine one can ride a snow machine, it seems Aroostook County, way up north, is where it's at. The trails are long and wide, with broad vistas beneath big, blue skies; one could almost mistake Maine for Montana.

If you're intrigued but uninitiated in the ways of the snow machine, there are dozens of places throughout the state where you can rent a sled. The tradition of snowmobiling in Maine has been around long enough to create its own backwoods industry, assuring that one can ride snowmobile trails throughout Maine (and into Canada and New Hampshire) over mountains, through valleys, and across rivers, lakes, and ponds and then spend evenings comfortably ensconced in B&Bs, inns, rustic cabins, motels, and hotels. See you at the Snodeo!

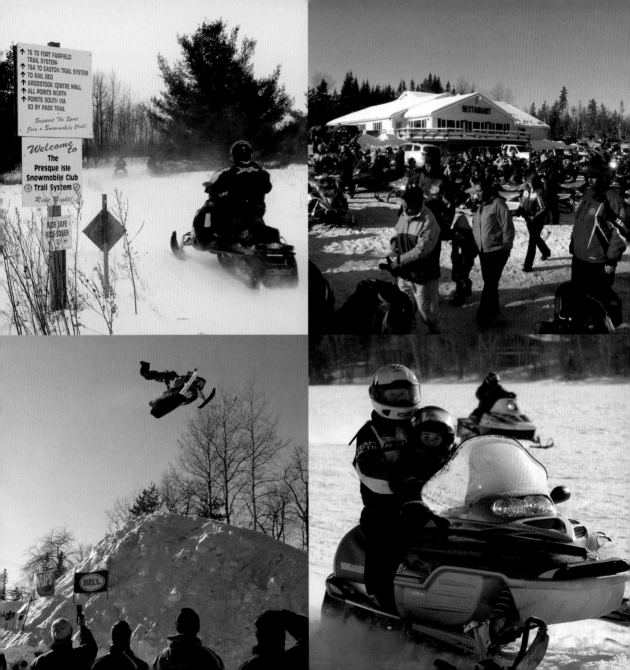

LIBBY CAMPS

How do you get to heaven? Well, if you're a fly fisherman, you'll want to head to township designation T8 R9, Maine. Make for the shore of Millinocket Lake (the farther north of the two), where you will find what you seek: Libby Camps.

The finest example of Maine's long sporting camp tradition, Libby Camps has been engaged for more than a century in what must be the state's oldest profession, or at least its grandest tradition, that of providing "sports"—those seeking to get away and pursue the plein air arts for a few days or longer—with quality fishing and hunting experiences. At the start, the outfit was called Atkins Camps and hosted such notables of the era as Teddy Roosevelt and Jack Dempsey as they pursued a bit of the rugged outdoors life—albeit with cabins and home-cooked meals.

In 1938 most of the cabins were moved from their location on an island in the middle of Lake Millinocket and resettled on the shore, their present location. Now, in addition to the eight cabins and main lodge, the Libby family also maintains eleven outpost

To get a sense of what makes Libby Camps so special, visit www .libbycamps.com.

cabins at remote ponds and lakes for sports who want a more solitary wilderness experience. Plus there's fourth-generation owner Matt Libby's statewide seaplane service, the Libby Camps lodgings in Labrador, Canada, and the contingent of Maine Guides Libby's employs throughout the year.

Meals are memorable events—hearty helpings of comfort food are served up family style as sports chatter about their latest lunkers and plans are made for the following day's outings. Though it hosts and guides bird, bear, moose, and deer hunts, Libby Camps is first and foremost a fishing camp. Sticking with that focus has been the company's strength into five generations of Libby ownership. But that doesn't mean that families of sports won't find plenty to do, including swimming, hiking, canoeing, or reading a good book while stretched out in an Adirondack chair on the lodge's long porch overlooking the placid lake. A suspenseful chapter may be interrupted, though, by the long, lonely call of a loon or a moose wandering across the lawn.

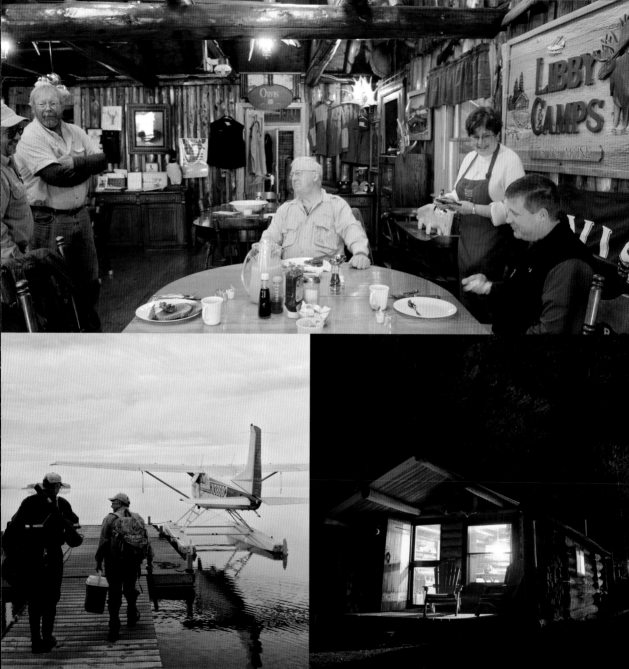

CHOWDER

The coast of Maine is dotted with clam shacks where you can find summer food stalwarts like hot dogs, shakes, fries, onion rings, and burgers—but the true star is chowder in all its flavors and thicknesses. There's clam, seafood, fish, corn, and while there are many variations on those themes, only in Maine do they all succeed, alive with taste and lingering in the memory long after a seaside visit is over. Variations notwithstanding, a good Maine clam chowder begins with the basics: It's milk or cream based, with chunked Aroostook potatoes, onions from one's own back garden, bacon or salt pork, and fresh-dug clams.

A chowder house trip up the coast yields a variety of vessels, from paper to Styrofoam with plastic spoons to locally made stoneware pottery and fine china with silver. Some eateries doll up their chowder with greens, but it's not a necessity. (A dousing of ground pepper is, however.)

Year-round chowder-centric events help keep the competitiveness levels amongst chowder houses at a fever pitch. The biggest, the

Always the third Friday in July, the Yarmouth Clam Festival is a three-day, must-attend Maine event: www .clamfestival.com.

Yarmouth Clam Festival, has taken place each year in mid-July since 1965. Bethel hosts a chowder cook-off in the fall, and Camden hosts chowder cook-offs in fall and winter.

What to pair with a steaming bowl full of chowdery goodness? Crackers, to be sure, but they have to be the right ones. Some folks make their own, passing down coveted family hardtack recipes; others swear by the little oyster crackers in cellophane baggies. Still others nurture fond memories (and dwindling hoards) of Nabisco's now-defunct Crown Pilot Cracker line—a commercial version of the traditional tooth-dullers, considered the ideal accompaniment to a bowl of chowder.

One thing people in Maine can agree on—tomatoes don't belong in a chowder. If it's red, you can be sure it came from Manhattan. Not that there's anything wrong with that . . . well, yes there is. Just ask the Maine Legislature of 1939, which passed a bill making it illegal to refer to that tomato-addled concoction as clam chowder. Chowder in Maine is serious business, mister.

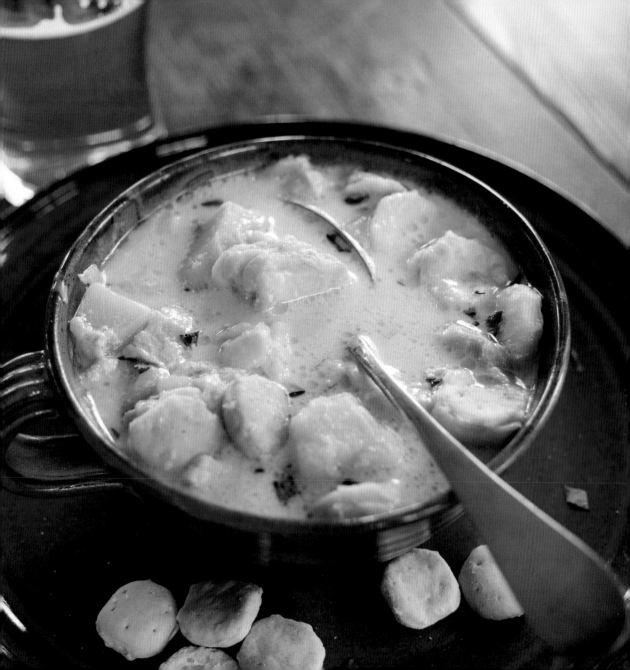

WOMEN OF THE SENATE

Maine has developed a history of electing strong Republican women to U.S. Senate seats. The first and most notable, Margaret Chase Smith, was born in Skowhegan in 1897. She held her husband's U.S. House of Representatives seat for nine years after his unexpected death in 1940 and then won an open U.S. Senate seat, which she held from 1949 through 1973. Chase Smith passed away in 1995 after serving twenty-four years in the U.S. Senate, for which she still holds the record as the longest-serving female senator in U.S. history. Chase Smith was also the first woman to be elected to both the U.S. House and the Senate and the first woman nominated for the U.S. presidency at a major party's convention (in 1964).

Senator Olympia Snowe was born in Augusta in 1947 and graduated from the University of Maine, Orono, in 1969. She married Republican State Legislator Peter Snowe and won his seat in the state house of representatives in a bittersweet victory in 1973 after his untimely death. In 1978 she was elected to the U.S. House of Representatives. In

Margaret
Chase Smith:
www.mcslibrary
.org

Olympia Snowe:
www.snowe
.senate.gov

Susan Collins:
www.collins
.senate.gov

1989 she married fellow Maine politico John McKernan, who was elected governor of Maine. While Maine's First Lady, from 1989 to 1995, Snowe was also elected to the U.S. Senate. In a lengthy and impressive career—more than thirty-five years in public life—Snowe has never lost an election.

Susan Collins, born in Caribou in 1952, was a high-school member of the U.S. Senate Youth Program when she visited Washington, D.C., and met with Senator Margaret Chase Smith. In 1994 Collins became the first woman nominated by a major political party for the position of governor of Maine. Though she lost that race, she went on to win a difficult U.S. Senate race for the seat of her former boss, William Cohen. Collins won the race and in 1997 assumed the Senate seat of her early mentor, Margaret Chase Smith. With each subsequent election, Collins has garnered a strong majority of the vote.

As of this writing, Senators Snowe and Collins are still Maine's indomitable senatorial force, representing Maine at the national level and building impressive legacies.

FRYEBURG FAIR

From humble beginnings in the chilly spring of 1851, the Fryeburg Fair has become Maine's oldest and largest annual agricultural event. It's a big deal on the Maine calendar, no matter how you measure it—a full eight-day week in early October—at an ever-expanding facility with an impressive infrastructure. And it all takes place on 185 acres of prime land in Fryeburg in the Saco River Valley, snuggled in the foothills of the White Mountains.

Attendance on that first agricultural get-together in March 1851 didn't quite reach the 300,000 figure it reaches nowadays, but there is historical proof that Lovell farmer William Walker won himself $3 for the best acre of corn and Brownfield farmer William Spring earned $1 for best seed wheat.

If those farmers could visit the fair today, they might not recognize the sprawling, flickering midway, but they would take comfort in the fact that livestock is still the most important aspect of the fair. Because of the fair's strong agricultural heritage, every beast

You'll find the fair in October on Route 5, Fryeburg; www.fryeburgfair .com.

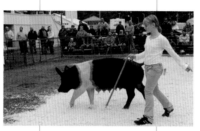

exhibited must register—more than 4,000 in 2008—with the fair's livestock office. The list includes dairy and beef cattle, oxen, horses, goats, llamas, all manner of poultry, plus rabbits, sheep, and swine. And that includes participants in the "Blue Ribbon Classic," the world's largest steer and oxen show, plus all those trotters in six straight days of harness racing.

For some folks the Fryeburg Fair is an anticipated annual event on par with Christmas and spring pea planting. Acres of parking lot—rolling fields that are hayed off for fair week—are converted into mini-cities each August with hundreds of motor homes, campers, and tents in which socializing ranks right up there with spectating the ox pulls. Some folks have camped in the same spot for decades; some travel thousands of miles to meet old friends, and others trek from the far side of town. And that dedication is what continues to make the Fryeburg Fair Maine's oldest and largest—and it shows no signs of slowing down.

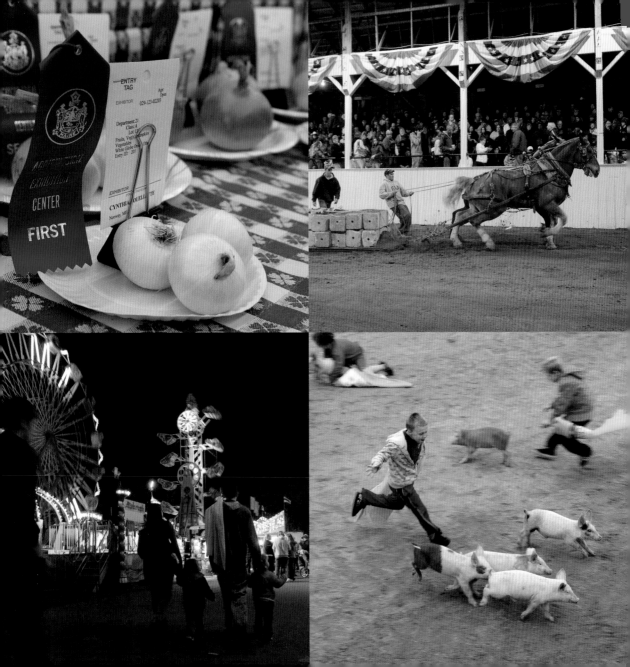

RED'S EATS

It's high summer and you're in Maine. There are any number of things you *can* do, but there's a shorter list of things you *must* do. Topping that list is eating a lobster roll, and the place to do that is Red's Eats on Main Street, Wiscasset, just over the Sheepscot River. You can't miss the little red building. But the location isn't nearly as important as what you'll find there: the state's—dare we say the world's—best lobster roll. Don't just take our word for it. Would Paul Newman and Tom Cruise lie? Yep, customers both.

Red, actually Al Gagnon, a jovial, charismatic man (who passed away in 2008 and who never had red hair—the stand was named Red's when he bought it in 1977), was so disappointed with a lobster roll from someone else's stand that he vowed to make one people wouldn't forget. And boy, did he suc-ceed. When you pick up your order at the window, from among seventy menu items, it'll be love at first sight. What you're getting is a honking big lobster

Hungry? Head on over to Main Street (US 1), Wiscasset; (207) 882-6128.

without the work. The rolls are lightly toasted then heaped with the chilled meat—knuckles, tail, and claws of at least one one-pound lobster—arranged just so in the bun, the claw meat poking out either end, the tail meat crowning the top. And each is served with a side of either drawn butter or mayonnaise. Mainers prefer butter—or nothing at all, so luscious is the fresh-caught lobster.

Annually Red's sells roughly nine tons of fresh-picked lobster meat. Debbie Cronk, manager of Red's East (and Big Al's daughter) tells her employees, who include seventeen local teens, "Don't measure it; just pile it on."

When it's all over and you're staring down at the empty tray on your table, take comfort knowing you can go back for more that day, and the next and the next . . . until Columbus Day, when the stand closes for the winter, opening again in spring by mid-April. Yes, there will be lines. But it's a small price to pay for perfection.

L.L.BEAN

By now, the story is near legend in Maine: In 1911 Leon Leonwood Bean, fresh off a hunting trip ruined by wet feet, sensed opportunity. With help from a local cobbler, he grafted leather uppers onto a pair of rubber work boot bottoms. He marketed his "Maine Hunting Shoe," and when ninety of the first one hundred pairs sold were returned because the bottoms separated from the tops, Bean refunded the purchasers' money by honoring the promise he'd made: "We guarantee them to give perfect satisfaction in every way."

Bean continued innovating outdoors products, and the company continued to expand its Freeport factory's footprint and the number of pages in its flyer. By 1937 annual sales exceeded $1 million. So dedicated was Bean to satisfying the sportsmen to whom he catered that he made himself available to them around the clock. This availability became so celebrated that in 1951 Bean announced to the public: "We have thrown away the keys to the place." And true to his word, the facility remained open

The door's never locked at the flagship store: 95 Main St., Freeport; (800) 441-5713; www.llbean.com.

twenty-four hours a day—a tradition the Freeport flagship store continues to this day, with no locks on the doors.

So revered was Bean that when he died in 1967 at age ninety-four, the Freeport corporate office received 50,000 letters of condolence. By 2010, L.L.Bean employed 5,400 people year-round, with 12,000 working to fulfill orders during the holiday season, and earned in excess of $1.5 billion in sales. And though it has stores all over the upper U.S. East Coast and as far away as Japan and China, various classic products, such as the Bean Boots and Boat and Tote Bag, are still made in Maine at two manufacturing facilities—Brunswick and Lewiston.

Though 2012 marks the centennial of the L.L.Bean Maine Hunting Shoe and the company, in Maine L.L.Bean is still regarded more as a kindly uncle than a corporation, and anecdotal tales tell why: It is true that families stranded in blizzards have several times over the years been allowed to slumber in the camping section of the store.

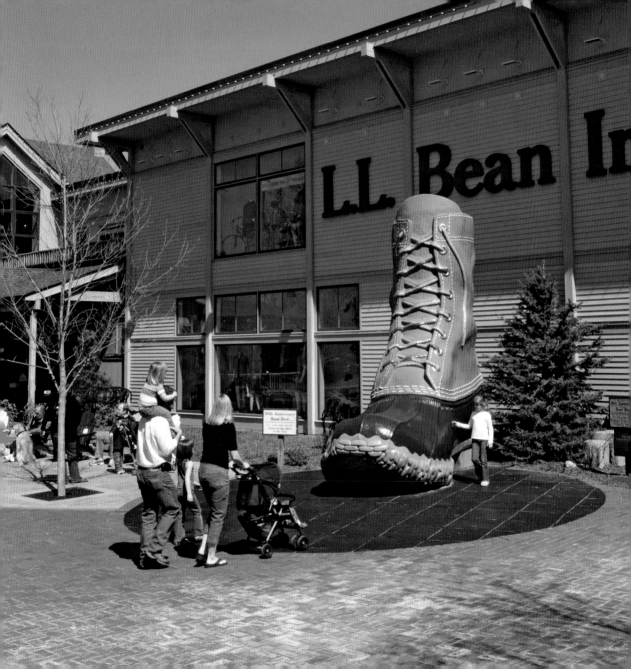

MOXIE

Moxie holds the honor of being simultaneously the world's most-loved and most-reviled soft drink. And it was born in Maine, despite rumors to the contrary. Moxie followers are fanatics, gaga for the gooey drink. Not quite cola, not quite root beer, not quite liquid licorice, it's a bizarre concoction that has pretty much tasted the same since its inventor, Union native Dr. Augustin Thompson, patented it *as a medicine* in 1876.

He claimed it helped with "loss of manhood, paralysis, softening of the brain, nervousness, and insomnia." In those heady early days, Moxie was taken just a spoonful at a time. As folks grew accustomed to the taste, bigger doses were required, and in 1884 Dr. Thompson tweaked the mixture to help it earn a place in the burgeoning soft drink market, calling it "Beverage Moxie Nerve Food." The bitter nectar was bottled and dispensed throughout the known world and became the first mass-marketed soft drink in the United States.

On May 10, 2005, Moxie was named by the state legislature as the

New England Moxie Congress: www.moxie congress.org

Moxie Festival: www.moxie festival.com

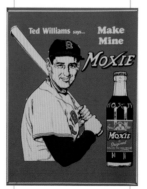

official soft drink of the state of Maine. And to further honor its inventive native son, the Union Fair is home to the Matthews Museum of Maine Heritage, an annex of which houses the world's largest collection of Moxie memorabilia, overseen by a band of fanatics known as the New England Moxie Congress.

The massive collection includes a 30-foot-tall wooden Moxie bottle and the truly bizarre Moxie Horsemobile, complete with life-size steed sporting a steering wheel.

Each July the tiny town of Lisbon Falls holds its annual Moxie Festival, a three-day affair loosely centered around the soft drink as its theme. And in Somerset County there's Moxie Gore, home of Moxie Stream and Moxie Falls, one of the state's highest waterfalls with a drop of more than 90 feet. It's located just 1.5 miles past Moxie Lake.

Any beverage that lays claim to helping with "softening of the brain" can't be all bad, even if it's an acquired taste. Just don't forget: When in Maine, be sure to say, "Make Mine Moxie!"

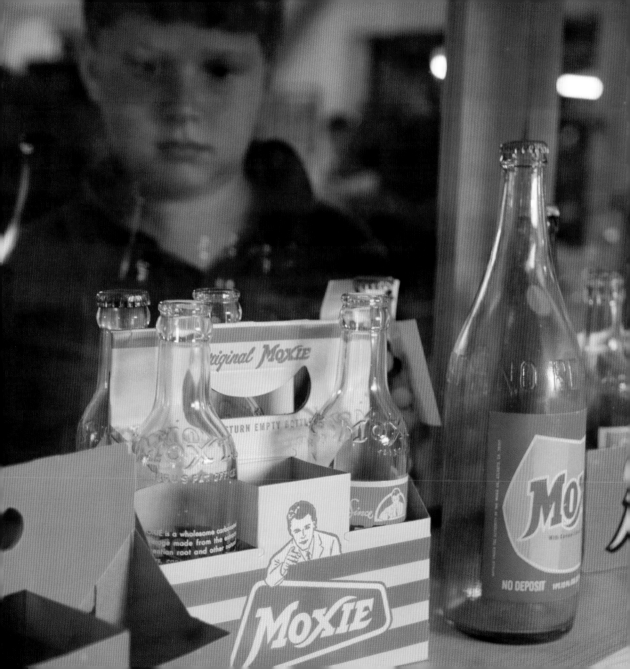

POTATOES

By early fall, roadside farm stands all over Maine are heaped high with brown and white bags cinched tight at the top and bulging with fresh-dug Maine potatoes. Though the entire state is closely associated with potato growing, by far the state's best spud landscape is Aroostook County; its rich layers of loam and cool, moist climate provide ideal potato-growing conditions. The industry kicked into high gear in the mid- to late nineteenth century when newly laid train tracks allowed farmers to ship their tubers to southerly markets. By the 1920s Aroostook County had become the world's biggest producer of potatoes.

And the tasty root is still a signature Maine product. Tallying in recent years 1.5 billion pounds harvested statewide on 60,000 acres by nearly 400 growers, potatoes are responsible for enhancing the state's economy to the tune of roughly $300 million. Aroostook County school kids still get three weeks off every September to help with the potato harvest.

Wood Prairie Farm:
www.woodprairie.com

Maine Potato Board:
www.mainepotatoes.com

Cold River Vodka:
www.coldrivervodka.com

In addition to more traditional methods, organic potato farmers have made great strides in the past few years. Notable among them is Wood Prairie Farm in Bridgewater. Their seed varieties grow tasty tubers—try the Adirondack Blue, a spud that's purple-blue straight through. It's the perfect way to grow a bit of Maine most anywhere.

If baking, mashing, and frying weren't enough, the folks at Cold River have come up with a new method of dealing with Maine spuds—distilling them to make award-winning vodka. And if you still haven't had enough of Maine's signature root crop, be sure to stop by Fort Fairfield (no one really stops by The County; it's a destination in itself, and the ride north is spectacular) in mid-July for the Fort Fairfield Maine Potato Blossom Festival, held when acres of beautiful white and lavender blossoms are in full bloom. Be sure not to miss the crowning of the Miss Maine Potato Blossom Queen, the mashed-potato wrestling, and a town-wide yard sale. And don't forget to try the spuds—baked, fried, or mashed!

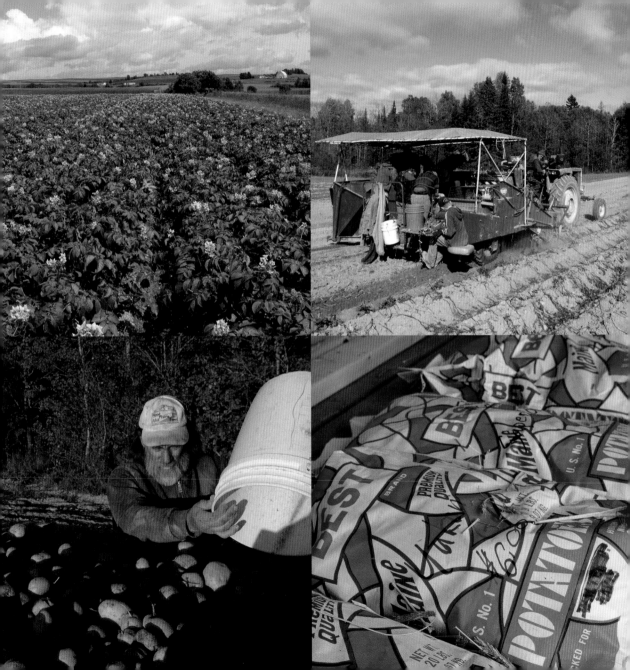

WHOOPIE PIES

Look, by the cash register . . . is it a . . . sandwich-cake? Heck no, it's a whoopie pie! And while its native region is up for debate (the Pennsylvania Amish claim it for their own; New Englanders politely disagree), these lip-smackin' treats have been baked and enjoyed in Maine for nearly a century. The classic whoopie pie comprises two cakelike cocoa cookies with a white, sugary vanilla cream filling squished in between. Add a glass of whole milk and you have a snack that is guaranteed to make you smile.

Labadie's Bakery in Lewiston has baked whoopie pies since 1925. In addition to a whoopie pie lineup that includes peanut butter, one of their best sellers is the Pink Whoopie with raspberry and coconut. Plus, Labadie's bakes the mother of all monster whoopies, an eight-pound brute that measures 16 inches across.

In recent years, even more extreme variations on the classic theme have popped up, most notably through the Gardiner-based company Wicked Whoopies. Begun in a home kitchen in 1994, it quickly grew from selling

Labadie's Bakery:
www.whoopie
pies.com

Wicked Whoopies:
www.wicked
whoopies.com

Moody's Diner:
www.moodys
diner.com

a dozen a week to 10,000 a day. The company now makes twenty varieties, including the classic whoopie, strawberry, gingerbread, banana oatmeal cream, chocolate chip, mint, red velvet, peanut butter, and maple. We hasten to add they are not all eaten by Mainers, though many are sold via three retail locations (Gardiner, Farmingdale, and Freeport). The others are shipped all over the United States.

Some of the best whoopie pies in Maine, however, are the homemade variety, which can be found at school bake sales and church fund-raisers and stacked in tottering pyramids beside cash registers at minimarts all over the state. Wrapped in cellophane and sporting a modest price tag (the baker is usually a local woman with a flour-dusted kitchen and a lucky husband), these cocoa and vanilla-cream concoctions are Maine's true road food, snapped up by loggers and lawyers, farmers and soccer moms, adding a confectionary kick to their daily routines. A cup of coffee and a whoopie pie, that's what gets Mainers rolling.

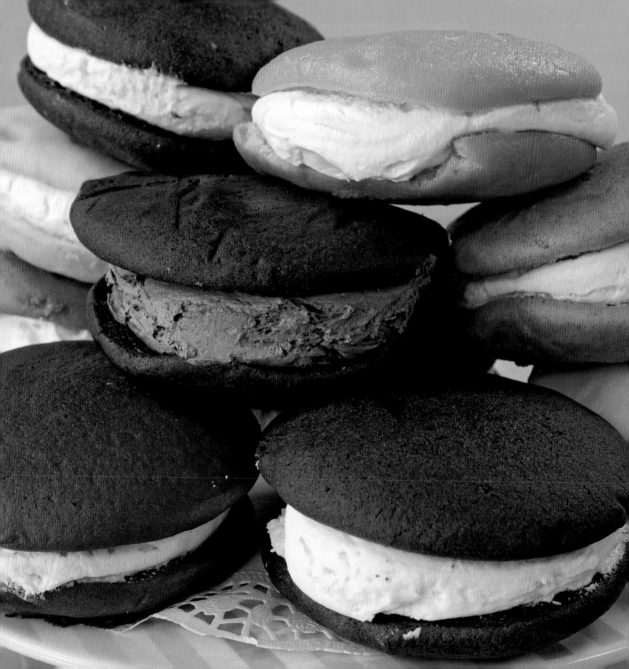

PORTLAND

In 1623 England's King Charles I magnanimously granted 6,000 acres of prime New World land—including a hellish good waterfront lot—to naval Capt. Christopher Levett, who was charged with the task of settling a community. After a few false starts and a couple of centuries, in 1820 Portland became the first capital city of the newly formed state of Maine. Alas, in 1832 the title of capital transferred to Augusta. Instead of lamenting the loss, Portlanders continued to make their hometown into a respected seaport.

In 2009 *Forbes* magazine named Portland "one of America's Most Livable Cities," a validation its 64,000 residents no doubt appreciate. Maine's largest city is, in fact, ideally sited—a short ride from miles of white-sand beaches. The islands of Casco Bay are as close as a ferry ride, and a handful of picturesque lighthouses, including Portland Head Light, are at hand. And let's not forget that there's water, water everywhere, with all its floating traffic: lobster boats, sailboats, sportfishers, kayakers, and numerous cruise ships that consider Portland a regular port of call.

Greater Portland Visitors Bureau: www.visit portland.com

Portland Downtown District: www.portland maine.com

Paralleling the bustling waterfront, the Old Port is a vibrant, artsy, cobbled district brimming with close streets, quaint and hip shops, galleries, and cafes. Portland is home to a wide variety of eateries, from humble hot dog stands to nationally recognized hot spots of haute cuisine. In fact, in 2009 *Bon Appétit* magazine named Portland "America's Foodiest Small Town."

The Portland Museum of Art is now in its third century of bringing fine artwork to Mainers, and the city is loaded with galleries, studios, and arts schools such as the Maine College of Art and Salt Institute for Documentary Studies. Portland also has her fair share of famous past residents, among them poet Henry Wadsworth Longfellow. And come April, the crack of the bat echoes at Hadlock Field, home of the Boston Red Sox–affiliated Portland Sea Dogs, with tickets ranging from $4 to $7. In winter the Portland Pirates semipro hockey team hits the ice and the Maine Red Claws basketball team hits the court.

Pretty good for a gift piece of land, eh?

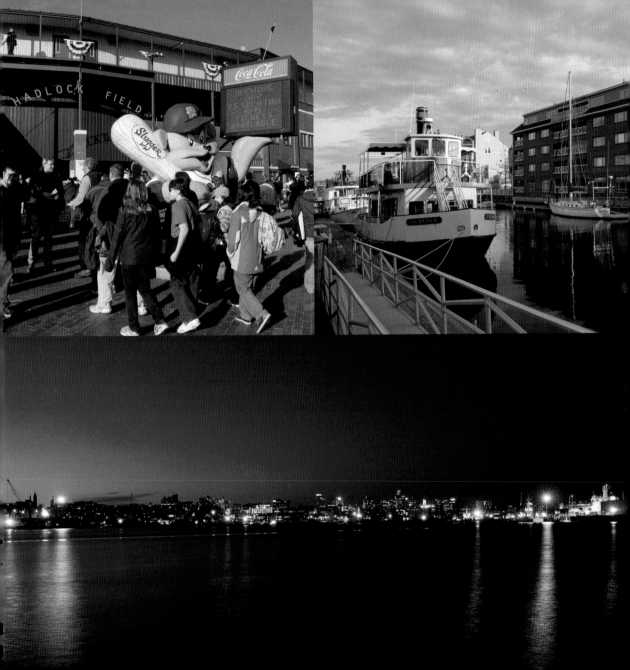

POLAND SPRING WATER

No matter how far you travel from Maine (which is always too far), Poland Spring Water makes sure that Maine is always close at hand. That's because although it's a global favorite, the refreshing liquid is still bottled from a pure Maine source. Several, actually. And it all began in 1795, when Jabez Ricker made a land swap with the Shakers and ended up with 300 acres and a house. Within a few years, the house became an inn, attracting the curious because of the water's reportedly restorative powers and the countryside for much the same reason. By 1845 the first water was sold to local shops in three-gallon clay jugs for 15 cents.

By 1860 Dr. Eliphalet Clark began prescribing Poland Spring water for patients with kidney and bladder disease. At the same time, the Poland Spring House, now a sprawling resort, thrived. In 1893 at the World's Columbian Exposition at the Chicago World's Fair, the water won the "Medal of Excellence," trumping "all other waters of the world." By 1895 the Ricker family had

Poland Spring: www.poland spring.com

Poland Spring Preservation Society: www.poland springps.org

been at Poland Spring for a century and managed sales and distribution offices in Maine, Boston, Philadelphia, and New York City.

In the early 1900s a Spanish architecture–inspired bottling facility and springhouse were built at the spring's site, attracting such rich and famous notables as W. C. Fields and Judy Garland. The fully restored facility, now known as Preservation Park, also includes a conference center, the Poland Springs Resort, All Soul's Chapel, and the Maine State Building, which houses the Poland Spring Preservation Society museum and gift shop. The stunning grounds of this New Gloucester complex are open to the public May through October.

Though Poland Spring Water is now part of the Nestlé empire, it will always be based in Maine because that's where that clean, clear, restorative water comes bubbling out of the ground. And Poland Spring Water, from little old Maine, is still one of the best-selling bottled waters in the world, with annual sales well north of half a billion dollars.

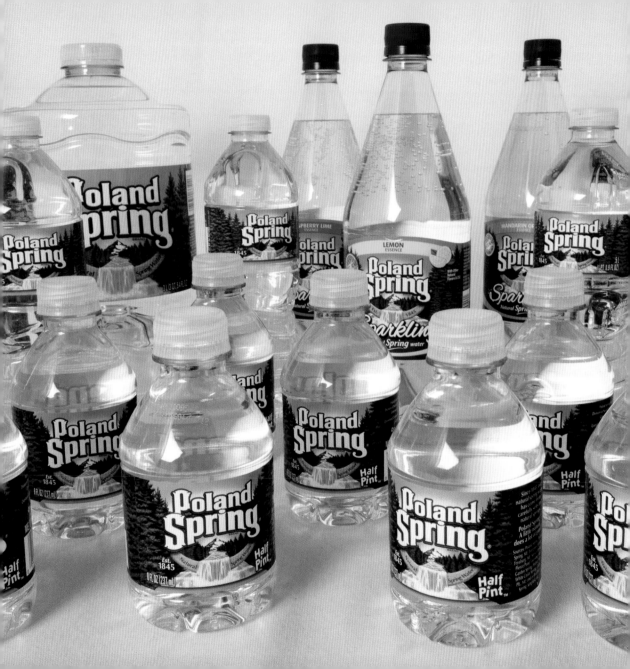

BATH IRON WORKS

Well into its second century, General Dynamics Bath Iron Works, or as it's known in Maine, "B.I.W.," has been a large and looming presence in the Pine Tree State for a long time—2010 marked its 126th year in business. Based in Bath, self-proclaimed "City of Ships," B.I.W. daily impresses commuters and tourists crossing the Kennebec River as they spy the series of massive cranes, the gargantuan warships in various stages of construction, and the sheer breadth of the sprawling riverside facility.

Begun in 1884 as a private shipyard, by 1890 it had won its first U.S. Navy contract for two iron gunboats. The 190-foot *Machias* was the first ship completed, and two years later the shipyard produced its first commercial contract, the steel passenger steamer *City of Lowell*—a 2,500-ton vessel that helped the shipyard land further valuable contracts for wealthy merchants. The shipyard went on to produce fishing vessels, trawlers, freighters, and yachts, though military contracts would take up increasing amounts of its time and resources.

General Dynamics Bath Iron Works: www.gdbiw.com

Maine Maritime Museum: www.maine maritimemuseum .org

During World War II, the yard reached its peak production and, incredible as it may seem, averaged the launch of a new destroyer every seventeen days. By 1981 B.I.W. had built its last commercial vessels and subsisted solely on military contracts. Its parent corporation, General Dynamics, employs roughly 82,000 people in a variety of locations and facilities. In recent years Bath Iron Works has focused its considerable engineering and manufacturing abilities on constructing a number of Arleigh Burke Class Aegis and Zumwalt Class destroyers. In addition, General Dynamics has expressed interest in exploring other industries and products that the highly trained workers at B.I.W. might help construct, among them cutting-edge energy production machines such as wind turbines.

Because B.I.W. is a secure industrial defense site, it does not offer tours of the facilities. However, during the summer and fall months, the Maine Maritime Museum (243 Washington St.) offers trolley tours of the B.I.W. shipyard. The museum's twenty-five acre waterfront site is well worth a visit.

LUBEC

In addition to being home to the state's most picturesque lighthouse, as the easternmost town in the contiguous United States, Lubec's grandest distinction is its proud claim as the first place in the United States to see the sun rise. While sun lovers perched atop Mount Desert's Cadillac Mountain might disagree, contesting the point with someone from Lubec won't get you anything but funny looks and a suggestion that you must be "from away."

Lubec's 97 miles of Atlantic coastline offer raw, rugged beauty that must be seen up close to be appreciated. Franklin Delano Roosevelt knew of the region's allure. Although he didn't live in that town, he did own a home on Canada's Campobello Island, just a baseball toss from Lubec across Passamaquoddy Bay.

Still very much a working fishing village, Lubec is proud of its maritime heritage. Though the canneries have disappeared from the Maine coast, at one time Lubec was considered the sardine canning capital of the world. Despite the inherent dangers,

When you've gone as far east as you can go in the United States . . . welcome to Lubec! www.visitlubecmaine.com

lobstering, sea cucumber harvesting, and urchin and scallop dragging remain strong contenders for most popular local livelihoods. In commemoration of local fishermen lost at sea, the town is planning to erect a fisherman's memorial statue depicting a woman and child looking seaward, standing atop a granite base inscribed with the names of lost Lubec fishermen.

Keep your peepers peeled along the Quoddy Loop drive—a scenic jaunt that swings through Trescott, Whiting, and Lubec, offering a diverse selection of plants and animals including bald eagles, moose, seals, puffins, and humpback, finback, and minke whales. In addition to views of the famous candy-stripe lighthouse, West Quoddy Head State Park offers hiking trails and picnic spots and is the ideal place to celebrate Lubec's 200th birthday in 2011. Back in 1811, Lubec split from neighboring Eastport, a community with which it still shares a good-natured rivalry over such things as school sports, fishing . . . and sunrises.

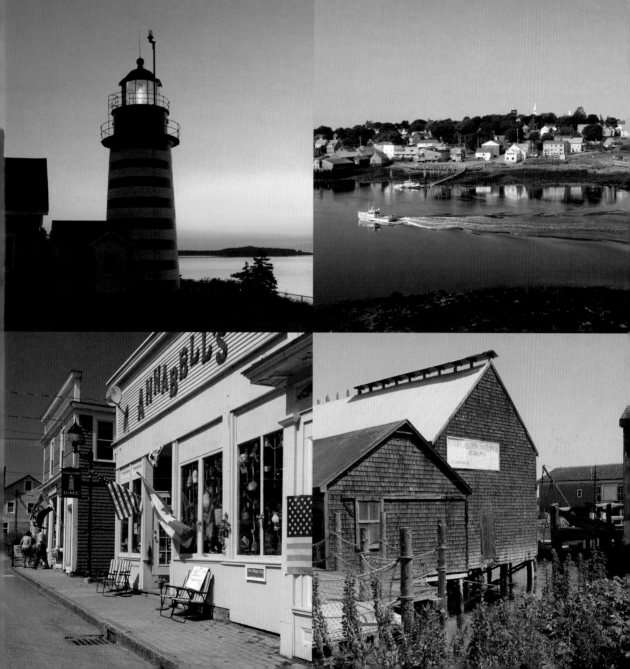

PHOTO CREDITS

All photos © Jennifer Smith-Mayo except: p. 10, © Courtesy Stephen King; p. 24 (Jamie & Andrew Wyeth) © M. B. Dolan; p. 24 (N. C. Wyeth by William Shewell Ellis, circa 19.11), courtesy Brandywine River Museum; p. 49 (Joshua Chamberlain), Library of Congress; p. 61 (Reny's Opening Day), Courtesy Reny Family; p. 71 © Down East Enterprise; pp. 80, 81 (Margaret Chase Smith), Library of Congress; p. 81, Courtesy Senator Olympia Snow; p. 81, Courtesy Senator Susan Collins; p. 86 © L.L.Bean Archives; p. 96 © Poland Spring Preservation Society; p. 98, 99 © General Dynamic Bath Iron Works.

ACKNOWLEDGMENTS

We wish to thank the following for their kind assistance during the compilation of this book: the Smith and Mayo Families, Dale and Barney, Deb Gautesen, Mary Beth Dolan, Jamie Wyeth, Bethany Engel, Farnsworth Art Museum, Dawna Hilton, Joe Anderson, Ranger Vietze, Peter Savage, Jason C. Libby, Carolyn Beem, Elizabeth Johnson, John Richter, Julia Lawless, Monty the Moose, Wayne McAtee, Donna and Norm Scheutzow, the Libby Family, the Reny Family, the Raye Family, the Red's Eats gang, the Wood Prairie Farm crew, the Moody's Diner folks, Flossie and Kendall Howard, Ron Greenwood, Farmington Historical Society, Ira and Ernest Kelley, Holly Davis, Steve Ketch, Harrigan's Seafood, Leonard's Mills, Alamoosic Lake Singers, Common Ground Country Fair, Paula Thorne, J. T. and the Wabanaki Arts Festival, Hatch Knoll Farm, the *Appledore* crew, Kevin Bennett, Big Chicken Barn, Tyson Dubay, Pat and Josh McCormac, Marc and Colby Johnson, Scott and Mason Philbrick, Hardy Boat Cruises, James and Michelle at Aroostook State Park, Little River Veterinary, Cooper and Gary Hiltz, the Libby Camps crew, John Healy, the New England Moxie Congress, and Wicked Whoopies!